Monte Zucker's PORTRAIT PHOTOGRAPHY HANDBOOK

AMHERST MEDIA, INC. ■ BUFFALO, NY

All rights reserved.
Published by:
Amherst Media®
P.O. Box 586
Buffalo, N.Y. 14226
Fax: 716-874-4508
www.AmherstMedia.com

Publisher: Craig Alesse
Senior Editor/Production Manager: Michelle Perkins
Assistant Editor: Barbara A. Lynch-Johnt
Editorial Assistance: Carey Ann Maines, Artie Vanderpool

ISBN-13: 978-1-58428-212-9
Library of Congress Control Number: 2007926861
Printed in Korea.
10 9 8 7 6 5 4 3 2 1

Notice of Disclaimer: The information contained in this book is based on the author's experience and opinions. The author and publisher will not be held liable for the use or misuse of the information in this book.

TABLE OF CONTENTS

ABOUT THE AUTHOR

Photo by Vincent Versace.

Monte Zucker was a photographer for nearly sixty years, producing wedding photography and portraits that are often credited as genre-defining works of the 20th century. In addition to membership in the elite Camera Craftsmen of America, he earned the distinction of being named as a Canon Explorer of Light. In 2002, he was also named Photographer of the Year by the United Nations.

Monte was recognized as a leading portrait teacher. In fact, many of today's leading photographers credit Monte as the original source for their photographic style. "I've always wanted to show others good technique and give them the ability to do what they feel," he said in an interview with *Professional Photographer* magazine. "I want them to be able to interpret a situation and put in on paper for others to share their vision."

THE ZUCKER INSTITUTE FOR PHOTOGRAPHIC INSPIRATION (ZIPI)

The goal of the Zucker Institute for Photographic Inspiration is to help young, at-risk children get involved with photography as a means of directing their energies. It is our hope that this will advance them toward successful and rewarding careers in the industry. To learn more about the mission, please visit www.montezucker.com and click on the link to the Zucker Institute for Photographic Inspiration. To support the work of the foundation, you can also purchase any of Monte's educational materials from the site. Additionally, a portion of the proceeds from this book will be contributed to this important cause.

INTRODUCTION

HOW FAR WILL YOU GO?

I am continually asking professional photographers (and aspiring professionals), "To what extent are you willing to put yourself out in order to become the best photographer that you can be? To what lengths are you willing to go to create the best portrait that you can make?" The answer keeps coming back, "Whatever it takes! I'm ready to go all the way."

I don't believe that any more—not for the majority of people with whom I have come into contact. People *say* that, but when push comes to shove, the answer really is, "Whatever it takes . . . as long as I don't have to put myself out too much." Many people really don't want to study/learn any predetermined technique. Instead, they say, "I want to be myself! Be creative! Be an individual! I don't really care about what other photographers have done in the past. I'd rather experiment and find out on my own what makes things work for me and my clients!"

Does this make any sense at all? Do you *really* believe that anyone can figure it all out by himself? To my thinking, it makes much more sense to get yourself a "coach"—someone who can see your strengths and help you grow from them, someone who can point you in the right direction so that you can achieve your maximum potential. Where would all of the world's great performers, artists, and athletes be today if they had not had proper coaching and training? If you think about it, what *doesn't* make sense is someone wanting to figure it all out by himself.

So, where do you stand on this issue? Are you willing to study—and study hard? To practice hard? To get the necessary equipment, however big or small it may be? It's not easy to achieve your maximum potential—but do you really want to settle for just "good enough?"

I have to think that if you're reading this book, you're at a point where you are ready to make your decision. So ask yourself, "Am I going for it? Am I willing to make the effort to learn proper technique and put it to practice? Am I willing to struggle through the growth stages of becoming a true portrait photographer and find my maximum potential?"

Perhaps, at this point you should pause and reflect on all of the above. If you're looking for the easy way to become a creative portrait photographer,

> Do you really believe that anyone can figure it all out by himself?

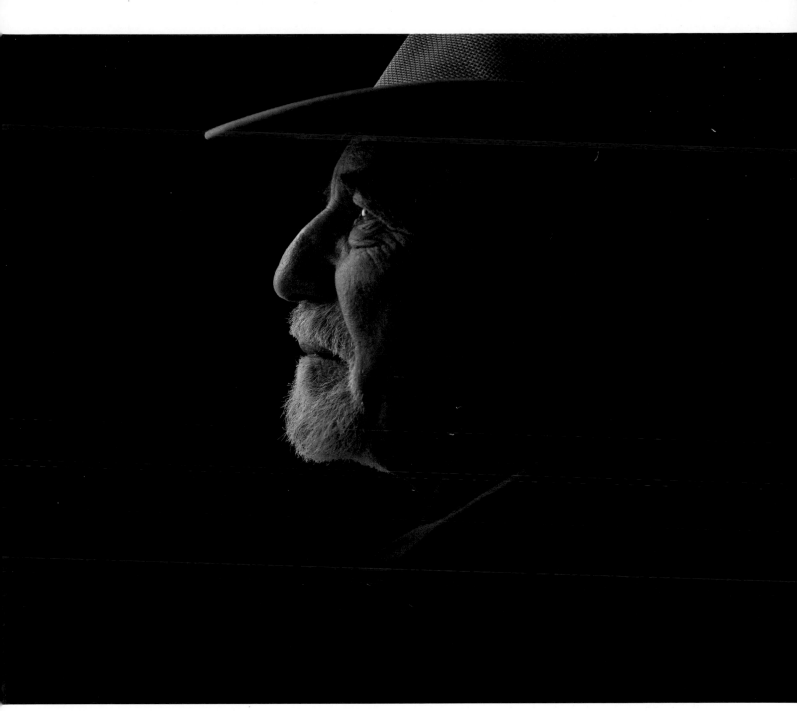

A Monte Portrait (the term I use for my work) is simple, elegant, void of distractions, and flattering to the subject. It makes a statement mostly about the subject, but at the same time reflects my interpretation of that person.

then continue to study here, to practice, and to grow. If, on the other hand, you decide that you'd rather make your life difficult, go ahead and learn the hard way—put this book away right now and try your own hit-and-miss techniques until you might stumble on something that will work once in awhile. It's up to you. Good luck in whatever you decide for your future.

SETTING GOALS

An effective portrait makes a dual statement—first, a statement about the subject; second, a statement about the photographer. An effective portrait is a successful combination of the two. If you look at a person's portrait and you are drawn into his or her personality—if you feel that you know something

about the person by looking at the picture—then the photographer has accomplished his or her goal.

For example, a Monte Portrait (the term I use for my work) is simple, elegant, void of distractions, and flattering to the subject. It makes a statement mostly about the subject, but at the same time reflects my interpretation of that person. A Monte Portrait is one that shows the subjects naturally, but also depicts them as I would like them to be. I can photograph reality when it suits the subjects, or I can idealize them when I feel it appropriate. Either way, it is a simple statement. I want you to *feel* a Monte Portrait as well as see it. If you are emotionally connected with my subjects when you see their portraits, I feel that I have done my job.

You should strive for this with every person that is in front of *your* lens. The only way to achieve it, however, is to master the technical skills that will enable you to concentrate on each subject—*without being held back by having to think consciously about posing and lighting.*

It is to this end that this book is being written. My goal is to give you specific instructions, step-by-step and in simple language, on exactly which angle of the face to photograph, how to pose the body, where to place the camera, where to position the lights, and how to expose the image for maximum detail in the finished print. If you study this material carefully and really work with it, you should be able to become the photographer that you want to be.

I should also note that, even if you prefer to take a photojournalistic approach to portraiture, you really need to understand the material in this book. Also, whether you want to work inside under controlled lighting situations or photograph outdoors, this book is for you. I will be detailing a practical approach to both styles of portraiture.

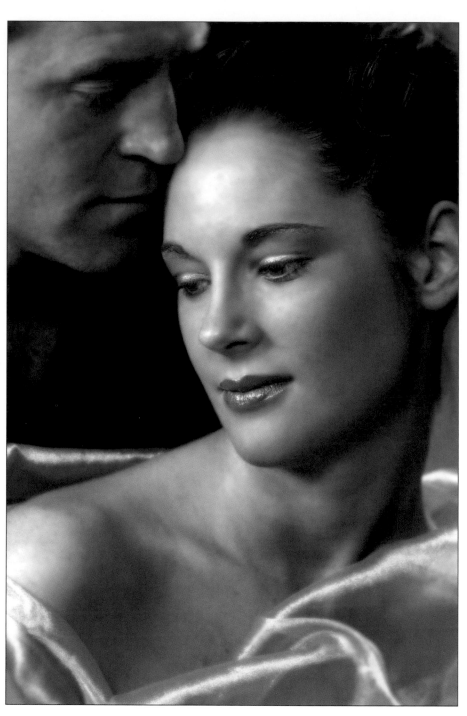

Can anyone really figure it all out by himself? To my thinking, it makes much more sense to get yourself a coach to point you in the right direction so that you can achieve your maximum potential.

1. PREPARING FOR THE SESSION

You can never allow people to use their own judgment for the clothing for their portrait. They will, undoubtedly, select their favorite clothing—and that clothing could (and probably *would*) be a total distraction from the face. Clients will also need your guidance when it comes to selecting the right hairstyle and using makeup that will photograph well.

CONSULTATION

A full clothing consultation before the shoot is imperative for achieving professional results. This should be done in person, not just over the telephone. Many people simply don't understand the necessity of preparing all the details for a portrait. It's up to you to convince them that your suggestions are for their benefit. Explain clearly and concisely the best choices for clothing and what to avoid. It may help to show them samples of portraits demonstrating good and bad clothing selections.

If people come to you for a portrait and their clothing isn't right, you have only yourself to blame—you either haven't explained things clearly enough or you haven't sufficiently emphasized the importance of careful clothing selection in the look of the final portrait. When this happens, *you* will have to bear the burden—you will have to either fix the problem or deal with a dissatisfied client. Am I making this statement clear enough to you? Again, how far are you willing to go to be the best that you can be?

So, would you still photograph the subject if you knew in advance that the person wasn't appropriately prepared for the portrait? That's up to you. You have to live with the results. I, personally, would do everything in my power to have everyone

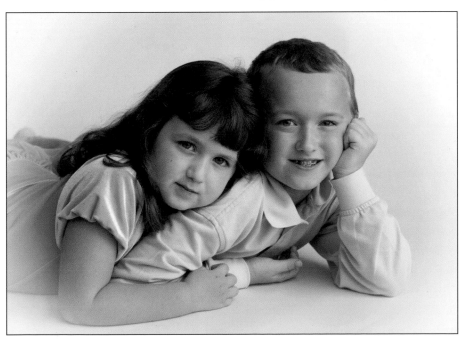

A full clothing selection before the session is critical to achieving professional results.

If necessary, you can create a quick "outfit" for the portrait by wrapping the subject in fabric—or even a feather boa. See page 13 for a variation on this technique.

prepared correctly for the portrait. Then, if all else fails, go ahead and take the picture. It doesn't make much sense to lose the sale, does it?

Of course, even with a complete consultation (and despite all your pleading), some people will still come to be photographed in clothing that is not really suitable for a portrait. For this reason, it's a very good idea to have some clothing on hand at your studio so that you can replace some of their choices with more appropriate, more flattering clothing. You may even want to have several choices of fabric on hand that you can wrap around your subject when proper clothing is not available. This can save the day in many instances and at the same time make for very nice portraits.

Higher necklines and V-necks are the most flattering choice for most subjects. Here, the bright color of the top is made less distracting by pairing it with a background of the same color.

RIGHT AND BELOW—Long-sleeved garments are a good choice for portraiture, as bare arms can be distracting.

CHOICES FOR CLOTHING

Sleeves. Short sleeves are definitely a drawback in studio portraiture. Bare arms draw attention away from the face. Advise your clients to select long-sleeved garments whenever possible.

Necklines. What about the neckline of a dress? Your eyes see from edge to edge of the flesh area that is exposed. Thus, a wide neckline tends to add weight to the subject in a portrait. A high neckline, a turtleneck, or a V-neck is much more flattering to everyone. When you explain this fact to your subjects, well in advance of the portrait sitting, you'll almost always get full co-operation from them.

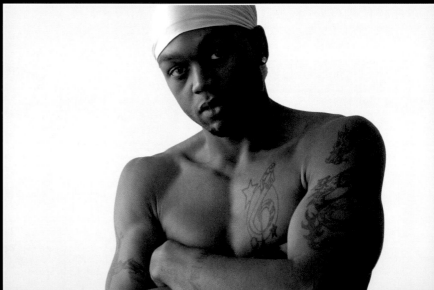

Sometimes, specific attire may be indicated to showcase a particular activity (top), a regional costume (left), or even to feature the subject's physique (above).

Colors and Patterns. Because most photographic backgrounds are subtly colored, the colors of clothing worn by your subjects should also be subtle. This allows the clothing to blend in with the background, keeping the viewers' attention on the subject's face. When used against most backgrounds, brightly colored clothing can draw attention to itself and away from the faces.

Does that mean that you should not use colored clothing in a color portrait? No. You can use color, but you must be aware of its effect. A few years ago I would never have thought that I would photograph a woman in a brightly colored dress; it would be too much of a distraction. I have, however, photographed a woman in a red suit and loved the results! Because she had on matching earrings and lipstick, it all held together beautifully.

The same goes with patterns; loud patterns in clothing can be a terrible distraction. However, if you photograph a person in a patterned dress and

> You can use color, but you must be aware of its effect.

When the clothing pattern matches the background (here, both are the same fabric), they blend together and leave your eyes on the subject's face.

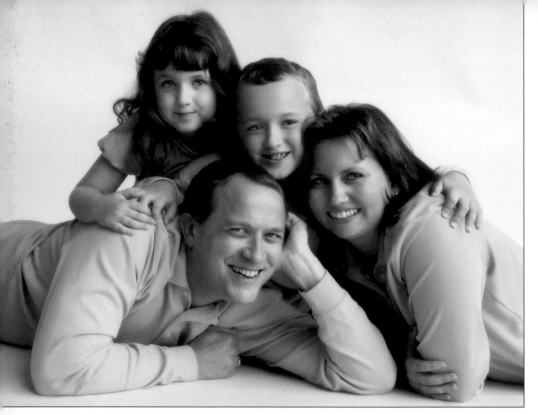

Matching clothes in solid colors help keep your focus on the faces in a family portrait.

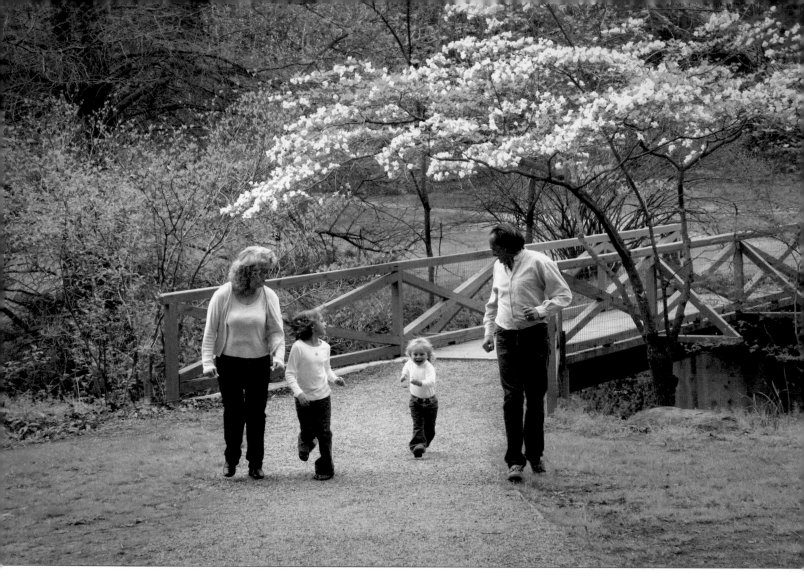

Make sure the dark color is worn on the bottom and the light color on top. This helps draw your eyes up to the faces.

put her against the same patterned background, then the clothing blends in with the background and your attention goes to the face. I do this sometimes when I wrap a model in a fabric and then have people hold up the same fabric for the background.

COORDINATING CLOTHING FOR FAMILY GROUPS

When planning a family portrait, I suggest that the group pick a color scheme for everyone and stick to it. Select either cool or warm colors and either light or dark tones. Mixing warm and cool colors or light and dark tones is disastrous to the final group portrait. The mismatched clothing definitely will take attention away from the family members. Patterns and prints should also be avoided as much as possible; they are a distraction.

Even in a casual outdoor portrait, it is necessary to blend the clothing together. Light blue and white work well together—just make sure that the light is in the top, and the dark is at the bottom. All white works well at the beach. Beige and white work well together outdoors. Even all black works well outdoors, but you have to be careful when lighting the group. Unless the light crosses over all of their clothing, you'll lose detail throughout the bodies and they will become a distracting mass of "nothing."

If the subject selects a classic hairstyle, it will help create a portrait with greater longevity.

Makeup should be selected

to enhance the look you

are trying to portray.

A very important part of every family sitting I do is to visit each group at home before they come in to have their portrait made. I ask them to spread out their portrait outfits on a bed. If anything jumps out, it's wrong for the portrait.

HAIRSTYLE AND MAKEUP

Hairstyle and makeup should be selected to enhance the look you and your clients are trying to portray. Professional hairstyling and makeup are extremely important, and they should be done by someone who is totally familiar with

what photographs well. Some artists overdo it to such an extreme that their efforts become a distraction rather than an asset to the subject. Be careful who you work with and who you recommend.

Hairstyle. When it comes to hair, a classic look is what is important. Caution your subjects to avoid fashionable styles; these will yield a portrait that is out of style in a short while. You should also avoid pieces of hair that hang forward on the face and create shadows, as well as hairstyles that cover the subject's eyes.

Suggest that a woman considering the hairstyle for her portrait do so with a light behind her head. Since there will probably be a light behind her when she is photographed she should be aware of how her hairstyle will photograph if there are lots of curls with open areas. This is usually very distracting in a portrait.

Makeup. Makeup is an absolutely necessary, but—unless you're going for a high-fashion look—it should not call attention to itself. I usually recommend foundation for women. This should be blended carefully over the jawline and onto the neck; an abrupt color change between the face and neck should be avoided. Mascara is almost always essential—even women who feel that they don't want makeup should at least wear mascara. A gloss lipstick is also important for making the lips look their best. If eyeshadow is worn, it should be used to define the eyes, not to call attention to the color of the eyelids.

When it comes to hair,
a classic look is what
is important.

Makeup should always be used in a woman's portrait. Unless you are creating a high-fashion image, however, you should strive for subtle enhancements with it.

2. BACKGROUNDS

A re you prepared to create portraits inside and out? Are you more comfortable photographing in the subjects' home environment or in a studio? Do you prefer painted backgrounds or more natural backgrounds? All of these choices should be discussed at the time of the client's clothing consultation. This is because the clothing and the background for the portrait are directly related to one another.

I suggest that you listen to your subjects' thoughts about what they're looking for before you make your own suggestions. Once a decision is made about the location of the portrait, choosing the best clothing should be easy—just pick something that will blend with the background and, in the case of

When photographing environmental images (inside or out) keep your subjects close to the camera and as far from the background as possible.

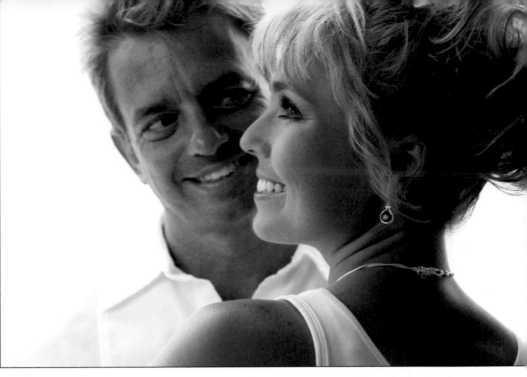

Sometimes a portrait with a solid background is what's called for, as in this white-on-white image. Here, a high-key image was created using a white scrim as the background. A reflector was added in front of the subjects to produce the proper lighting ratio.

group portraits, that will help the subjects blend with each other. When you do this, the faces will stand out in the portrait.

OUTDOOR/ENVIRONMENTAL BACKGROUNDS

Although outdoor portraiture is very much in vogue, it creates more problems for the photographer than working in a totally controlled environment.

Creating an environmental portrait does, however, allow you to include more in the background than when photographing in a studio environment. Because this means the people are smaller in the frame, it also creates the potential for selling a much larger finished image.

But how do you keep the background from overpowering the people in your pictures? When photographing environmental images (inside or out) keep your subjects close to the camera and as far from the background as possible. If you want both the subjects and the background to be in focus, use a wide-angle lens and focus on your subjects. In most cases, a wide angle has enough depth of field for both the subjects and the background to be sharply rendered.

For location shoots, I always carry a background with me—regardless of what I plan to do in the beginning. I never know when I may want to create a portrait with a solid background. Even when photographing in beautiful locations, it's always possible that you may want to offer the client a second choice of portrait styles. My current choice is a simple foldout screen that's black on one side and white on the other.

PAINTED BACKGROUNDS

There is some controversy about whether or not to use painted backgrounds. Some clients may have a negative attitude toward painted backgrounds because they have seen some of the outrageously painted ones—backgrounds that actually detract from the portraits. This perception can cause them to as-

> But how do you keep
> the background from
> overpowering the people?

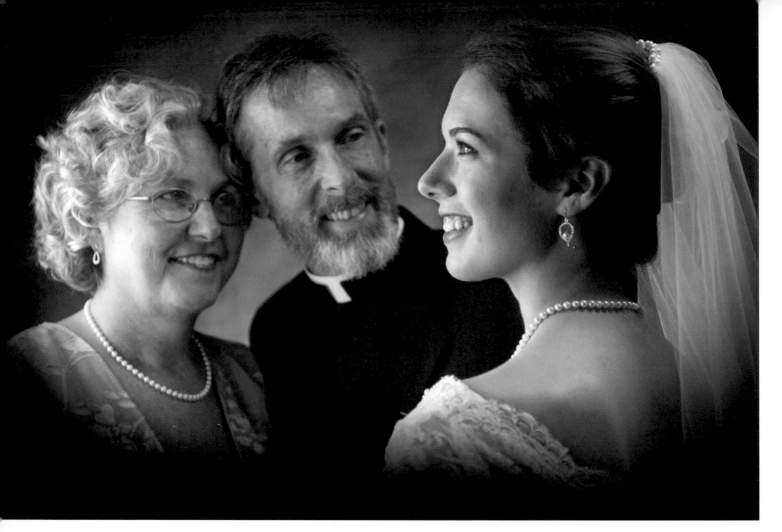

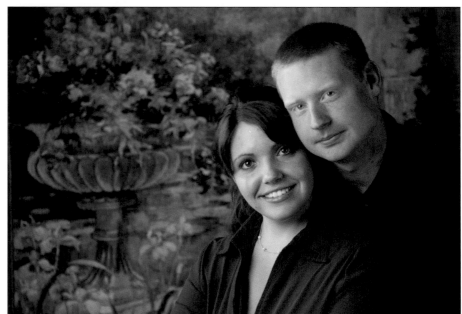

ABOVE—With painted backdrops, cooler tones tend to recede and help keep the viewer's attention on the warmer tones in the image—namely, your subject's skin tones.

RIGHT—Using a painted background that has attention-getting colors and patterns will definitely create a statement, but it is not right for every image.

sociate painted backgrounds with inferior portraiture. Of course, from the photographer's viewpoint, we want to please our clients. Therefore, we should certainly take their feelings into consideration before making any decisions. It is possible, however, that the client may not know what is best for their portrait. You may, therefore, actually decide to try both options, shooting images both with and without a background.

Assuming that you are going to using a painted background, what color and style is best suited for you and your clients? My choice for a subtle background color is one that is cool in tone, preferably one that is greenish. Why

green? As a cool color, green will recede in the portrait and not compete for attention with the warmer skin tones. Against a cool, green background, the subject's skin tones will appear richer and rosier, regardless of whether the person is light or dark completed.

What about other cool colors—blue, for instance? That can work. Still, remember that if the color or design of the background calls attention to itself, then you're making an additional statement in your photograph. Warm, brown backgrounds compete for attention with the flesh tones and actually take away from the subject. Personally, I avoid them.

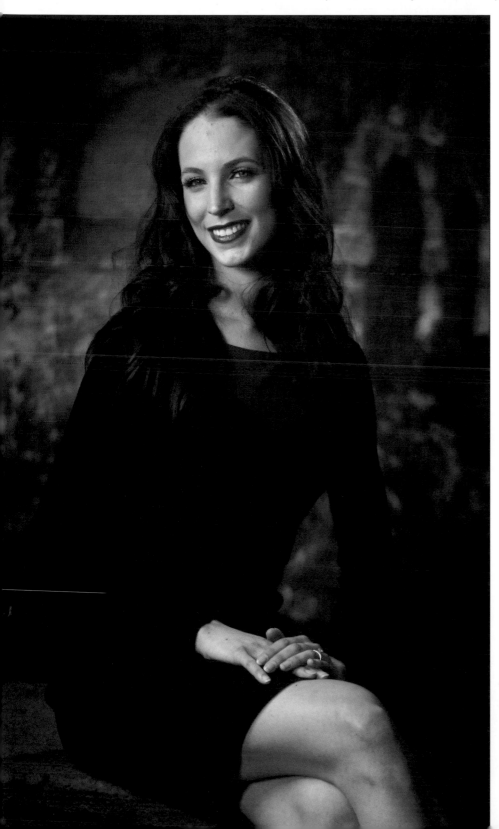

Projected backgrounds offer limitless possibilities for studio portraits.

Denny's Manufacturing Co. ([800] 844-5616; www.dennymfg .com) is the best supplier that I have found for painted backgrounds, as well as for more elaborate backgrounds and props. Together with Denny's, I have designed a background, called the Monte Green (OM2331), that suits all my needs. It's lightweight and mounted on a crossbar with a hole in the middle. When placed on a single stand it can easily be moved by one person. When mounted with a stand on each end, moving this type of background requires an assistant.

PROJECTED BACKGROUNDS

Projected background systems have been refined to such an extent that they can be a great addition to your studio's offerings. Stock slides or slides made from your own digital files can transport your subjects to just about any location in the world. Abstract artistic backgrounds can also be created by many computer programs for use with these systems.

I've tried the Virtual Backgrounds ([800] 831-0474) projection system and found it very easy to work with. I've also seen many beautiful and imaginative portraits created with this system. I've even created a few portraits of my own using this system—and I'm preparing a number of

If you use projected backgrounds, keep your eyes open for scenes and subjects that you can photograph and then use as backgrounds for future portraits.

As a travel, I try to take pictures to use as projected backgrounds.

images that I plan to transfer into backgrounds for future use. As I travel, I try to take pictures with no one in them to use in the future as projected backgrounds.

CONTEMPORARY CHOICES

A great addition to my selection of backgrounds are tapestries made by Portrait Weavers ([800]233-0439 or www.portraitweavers.com). You can use something from their catalog or order tapestries made from your own photographs. These tapestries, which can be made featuring an image from their session, are also great products to offer your clients.

Another of my favorite new background is one that stretches onto an 8x8-foot frame. It's great for people who don't want the look of a painted background. This is a two-ply background; one piece is white and an attached

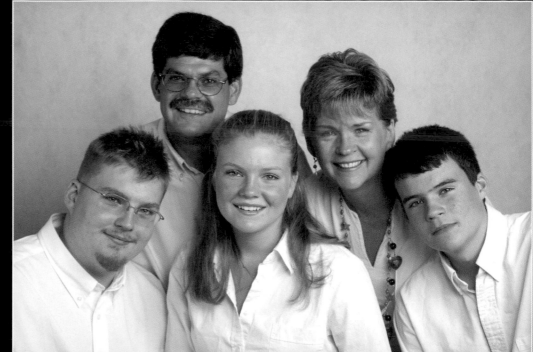

These portraits were created using the Superlite background, which stretches onto an 8x8-foot frame.

fold-over piece is dark gray. When stretched and put into position it is wrinkle-free (personally, I do not like muslin backgrounds that show distracting folds and/or wrinkles). You can adjust the tone of the background by controlling the amount of light that falls on it in comparison to the amount of light on the subject. By reducing the light on it, the white background can be rendered in all tones of light to medium gray. The other side can go from medium gray to black by reducing the amount of light allowed to fall on it. These backgrounds are made by Diane of Superlite Custom Backdrops ([516]746-0818; www.superlitebackdrops.com). The stretcher frame can be ordered at (414)481-2128. The whole setup weighs less than a couple of pounds and fits into a lightweight 36-inch carrying case. Wow!

My most practical and convenient foldout background, a Westcott 5685, is simply white on one side, black on the other. Again, both sides can take on

For a simple, solid colored background, this is a good choice. This shot was created using the Westcott 5685 foldout background, which is white on one side and black on the other. Here, the white side was used.

Here, the black side of the Westcott 5685 foldout background was used as a low-key background for the portrait.

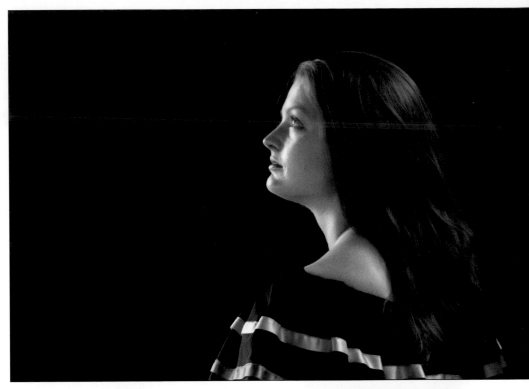

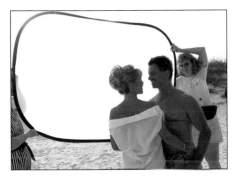

A translucent panel served as the background for this beach portrait.

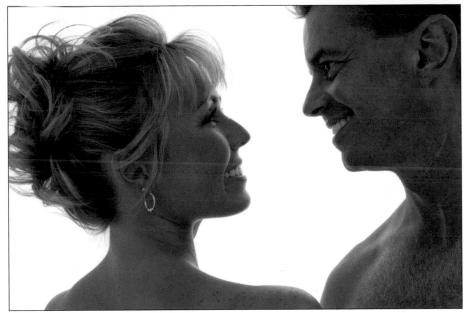

different tonalities depending on how they are lit. A white background, for instance, can photograph white, gray, or even blue. A black background can photograph differently, too, depending on the angle at which the light hits the background or how much light you put on it. If you overexpose a black background by two or three stops, you can make it photograph gray. This device is ideal for a background when you really don't want *anything* in the background. As a matter of fact I call it my "No Background at All!"

Another personal favorite is a foldout translucent panel (Westcott 1707) that I can use either as a background or to break down bright, direct sunlight into a soft, diffused light source that is ideal for portraiture.

More brilliantly colored backgrounds, or backgrounds with designs, can also be used effectively for a contemporary look. In many instances, brightly colored backgrounds can actually enhance the portrait. Careful use of offbeat backgrounds can be a beautiful asset to a composition. Senior portrait sittings, for instance, can be greatly enhanced with a large selection of vibrant backgrounds. The trick, of course, is to have enough knowledge to judge whether or not the background is an effective and integral part of the portrait.

In special situations, a very brightly colored background may work

3. THE SUBJECT

When I ask photographers what goes through their minds when they begin to create a portrait, I usually hear vague comments but nothing with substance. It seems to me that photographers have never had any definite guidelines to follow when starting a portrait. That's why I'm beginning with what everyone should know. You should begin by studying your subject's face—and a few specific features in particular. After just a few moments, you will actually know exactly how you're going to photograph each and every one of your subjects.

Begin your analysis with the subject turned straight toward you.

DOING A FACIAL ANALYSIS

Begin your analysis with the subject turned straight toward you. Look at the full face. Then, turn the head and body slightly, viewing the face from an angle. Finally, turn the subject still more to see the side view. You can accomplish a similar effect by changing your own viewpoint, rather than asking the subject to move. Repeat this evaluation to view the other side of the subject's face.

What you're looking for is how the face seems to change as you view each specific angle. When viewing the full face, be sure to have the subject facing straight at you. Examine the hairstyle, the size of both eyes, and how a change in their expression changes the size of the eyes and the outline of the face.

Eventually, you will be able to do this analysis while simply holding a conversation with the person. Of course, this makes your subjects more comfortable than when they are aware that you are studying their faces.

It is important to determine the best angle at which to create your subject's portrait.

Once you've decided to photograph either the left side or the right side of a face, stick with your decision. If you photograph a person from every conceivable angle, you will only tend to confuse them when it comes to making a selection. If you're totally unsure, of course, then go for both sides of the face—but I rarely do that.

DETERMINE THE BEST ANGLE

Since each face has its own special characteristics, it's important to know how you can best determine the specific angle that will be the most flattering to a given subject. There are basically three angles of view to consider.

Full Face. This is the view you achieve when looking at the face straight-on. When they are not covered by the subject's hair, *both ears will show equally in this view.*

Even if you're beginning a portrait sitting with a full face, you should think about which way you're going to turn the face for the two-thirds view. Think about the easiest way to go from one facial view to the other without having to switch the main light from one side to the other.

Two-Thirds View. A two-thirds view of the face is achieved when the head is turned to the side, leaving both eyes visible from the camera position. The

ABOVE—The full-face view is achieved when the subject is looking straight at the camera.

FACING PAGE—A two-thirds view of the face is achieved when the head is turned to the side, leaving both eyes visible from camera position. The two-thirds view usually slims the face, making the cheekbones stand out more. When you use this view, you'll find that round faces will seem more oval.

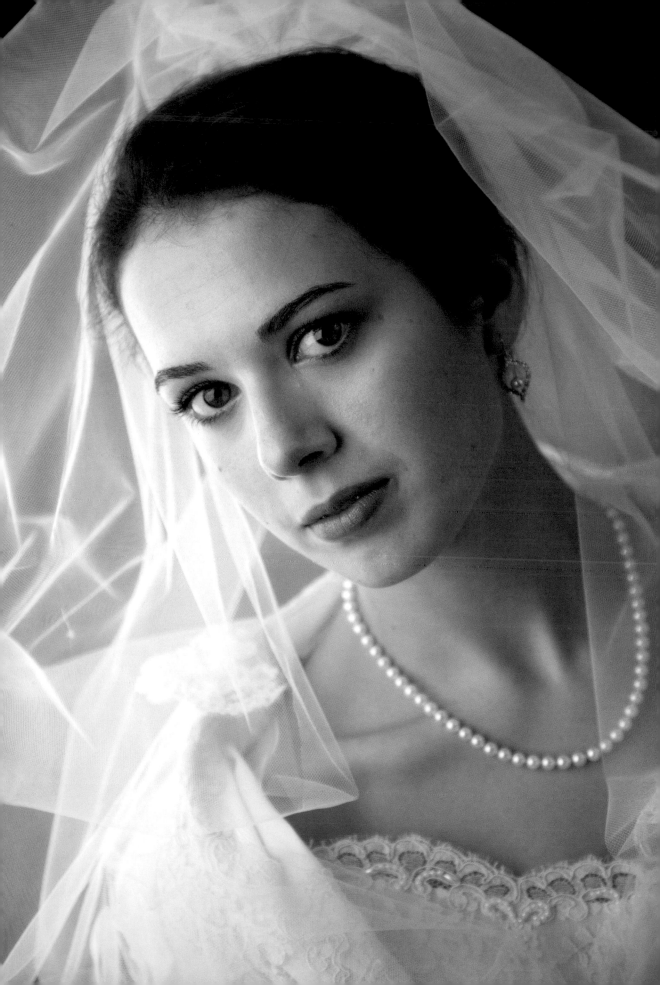

eye on the far side of the face should go almost to the edge of the outline of the face, but a small amount of flesh should still separate this eye from the background. The tip of the nose should be contained within the outline of the cheek; it should not come close to the edge of the face or cross over the outline of the face and protrude into the background.

In this facial view, the bridge of the nose should not cover any of the eye on the far side of the face. If the subject's nose has a high bridge and it begins to cover the eye, you must ease the face back slightly toward the camera position.

The two-thirds view usually slims the face, making the cheekbones stand out more. When you use this view, you'll find that round faces will seem more oval. This view can also be used to provide considerable softening for subjects with a square jawline. It also has advantages for subjects with protruding ears; it causes the ear on the far side of the face to disappear, while the ear closest to the camera position seems to flatten out against the side of the face, minimizing its appearance.

The tip of the nose should be contained within the outline of the cheek.

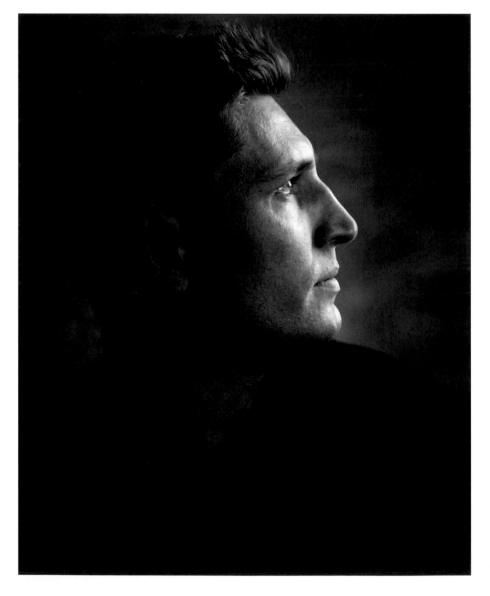

In a profile view, you see exactly half of the face.

Profile. In a profile view, you see exactly half of the face. To achieve a pure profile turn the face away from the camera until the far eye and eyebrow both disappear. If they are long enough, you may see the eyelashes of the second eye, but this is is unimportant. All that really matters is that you see an exact profile. Once you have your subject posed for a profile, be sure to reposition any hair that may be showing on the far side of the face—especially below a woman's chin.

Many people think that they are looking at a profile when they're actually viewing slightly more or less than the side of the face. If your subject is turned too far away, you'll be showing more of the back of the head. When the subject is not turned far enough, you begin to see some of the far eye—plus some of the flesh beneath the nose. Obviously, both of these problems tend to detract from the outline of the face.

In a profile position, the entire shape of the face seems to be dramatized. Even subjects with a "less than perfect" nose often look very good in a properly lit profile (more on that in chapter 7). Just think of some of the famous profile portraits you've seen.

ADDITIONAL CONSIDERATIONS

Hair. As you look at the different views of the face, take into consideration the difference your subject's hairstyle can make. If the hair looks better from one side than the other, then I would certainly consider photographing the subject with that side toward the camera. I usually photograph the fuller side of the hair, rather than photographing into the part.

Eye Size. Always take note when a subject has one eye that is smaller than the other. When you find that, you can make them appear more equal in size by turning the smaller eye away from the lens. The reason for this is that the eye is basically almond-shaped; it is wider in the center than on the outside edge. When the smaller eye is turned away from the lens, the larger part of the eye will be toward the camera. Conversely, when the larger eye is turned toward the lens you will be looking at the smaller part of that eye. Thus, the two eyes will appear to be more equal in size from the camera's viewpoint.

Noses. Some subjects have a bump or curve in on one side of their nose, while the other side of the nose is straighter. To disguise this, light the curve or the bump, placing the straighter side of the nose against the shadow. The curved side of the nose (facing the light) will tend to flatten out when the light hits it.

Follow Your Instincts. What happens when the hair, the eyes, or the nose tell you to turn the subject's head in one direction and one of the other guidelines tells you to turn the head the other way? Then, you simply have to make a judgement call; determine which guideline is more important and follow your instincts. I look at the hairstyle first, since that is the most obvious element in the portrait. I follow with a study of the eyes. Lastly, I look at the nose.

Take into consideration the difference your subject's hairstyle can make.

4. POSING FUNDAMENTALS

The pose is not the picture, it's merely the support for the face. In fact, you're usually never even aware of a *good* pose; it tends to go unnoticed. A *bad* pose, on the other hand, calls attention to the discomfort and awkwardness of the subject.

While a good pose takes into consideration how best to flatter the subject, a bad pose is one of the things that causes people to say, "I hate the way I look in pictures!" This is what causes many people to think that the only way they will be happy with their picture is when it is entirely *unposed*. Don't believe them. It's not the *lack* of posing that actually makes them think they look better—it's the fact that unposed pictures are usually made from afar. What these subjects are actually objecting to is not *being* posed, it's *looking* posed. Although they may think that they want to look "natural," given the choice between "being themselves" or looking their best, they'll always opt for looking their best. This makes it critical that you know how to position people so that they look natural—and that you can explain to them what you're doing and why. And keep in mind your bottom line; the photographs your clients will actually buy are always the ones that depict them in the most flattering way.

A good pose takes into consideration how best to flatter the subject.

BASIC PRINCIPLES

When positioning a subject for a portrait, determine the facial angle you're going for. Next, decide if the person is going to be in a basic pose or a feminine pose (see pages 34–39).

Seating. Tell your subject exactly which way to face when they sit. Most photographers ask their subjects to sit and then rearrange them. You will look a lot more professional when you are very explicit: "I'd like you to sit down facing *this* direction—without moving the stool, please."

Body at an Angle. Be certain that the body is at approximately a 45-degree angle to the camera. When you are first learning to put the body at that angle, you may want to start with the subject's body at a 90-degree angle to the camera with the shoulder directly facing into the lens. Bring out the back elbow to achieve the lean of the body and create the high/low shoulders (see page 34). Once this position is achieved, you can turn your subject slightly

FACING PAGE—Placing the subject's body at an angle to the camera creating a slim view.

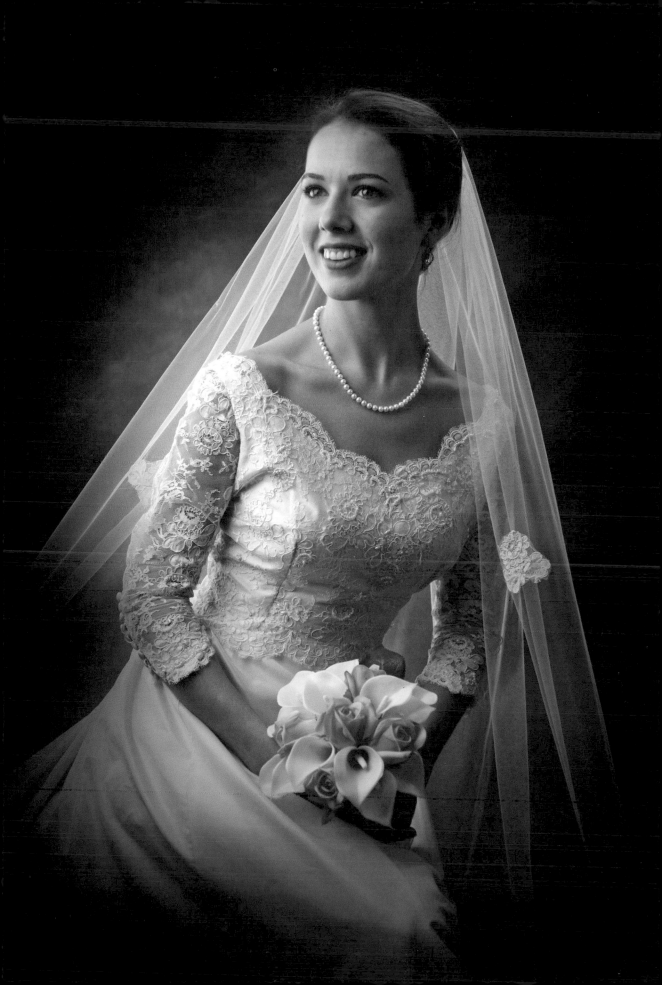

back toward to camera. If you begin *without* positioning your subject at a 90-degree angle to the camera, you'll more than likely end up with the subject's body facing straight into the camera. That usually adds a lot of weight to the subject—*not* a good idea!

The Shoulders. In both the basic pose and the feminine pose (see below), the seated subject leans forward toward their knees. This automatically lowers the shoulder farthest from the camera position. The slope of the shoulders is important for good composition.

Posture. Just before the exposure is made, the subject lifts to his or her fullest height to achieve better posture. Care should be taken to see that the person's shoulders are still relaxed downward, however. In the desire to sit erect, people tend to lift their shoulders. Be aware of this, and gently tap them to relax their shoulders.

In the basic pose, the head and body go in the same direction: toward the main light.

TWO SIMPLE POSES

I have borrowed from the "classics" and come up with two simple poses that seem to repeat themselves in the art forms that have survived for centuries. For simplicity, I have named them the basic pose and the feminine pose.

First, however, let me start off this section by pointing out that *knowing* and *doing* are two different things. Many people tell me that they know all about the basic pose and the feminine pose. Yet, they don't apply those principles in their portraits. Knowing about them and applying the principles are two distinctly different things. If the ideas aren't applied, there's no sense in knowing about them, is there?

The Basic Pose. The basic pose is sometimes referred to as the masculine pose, but it is actually good for everyone—male or female. It is particularly useful for women who are heavy, because when the head is tipped to the low shoulder, the fullness around the jawline and neck disappears. The basic pose is one in which:

The basic pose is sometimes referred to as the masculine pose, but it's actually good for everyone.

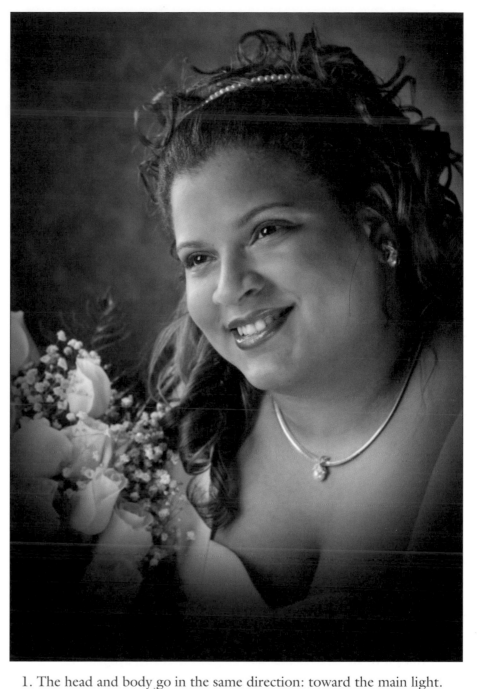

1. The head and body go in the same direction: toward the main light.
2. The head is tipped toward the lower shoulder, so that the head is perpendicular to the slope of the shoulders. (*Note:* A common mistake is having the head straight up and down; this tends to make the pose look uncomfortable.)
3. The body is at a 45-degree angle to the camera.

Make certain that the subject is on the forward edge of the seat . . .

To use the basic pose, seat your subject on a stool at a height that will allow the knees to be slightly lower than the waist. Make certain that the subject is on the forward edge of the seat, so that the foot farthest from the camera can rest on the floor. The subject will need the support of that back foot when leaning forward at the waist, as noted above.

For the basic pose, the subject's shoulders should always be at a 45 degree angle to the camera. Less of an angle (*i.e.,* with the subject turned directly toward the camera) tends to broaden a person's body too much in the final portrait. Conversely, turning the body more than 45 degrees away from the camera would necessitate turning the subject's face back to the lens so much that it would be impossible to keep the face flowing in the same direction that the body is facing. In such a position, the basic pose would be impossible to create.

The basic pose works only for full-face and two-thirds view portraits. When photographing a profile, you must switch over to the feminine pose (for both male and female subjects). A profile needs a broader base, which is achieved only with the feminine pose.

The Feminine Pose. The feminine pose creates an elegant look for slim women; it does not usually work for heavier women, because the tip of the head toward the high shoulder can create folds around the jaw. It can, however, occasionally work when posing a heavier woman in a two-thirds view.

Other than for the profile, you should also avoid the feminine pose for all men. The best way to do this is to make certain that the male subject's body is turned toward the camera enough that he will not have to turn his head back in the opposite direction from his body to look into the lens.

The feminine pose is one in which:

1. The head is turned and tipped to the high shoulder. (*Note:* To avoid distortion, the head should be turned until the cord in the neck just

> The basic pose works only for full-face and two-thirds view portraits.

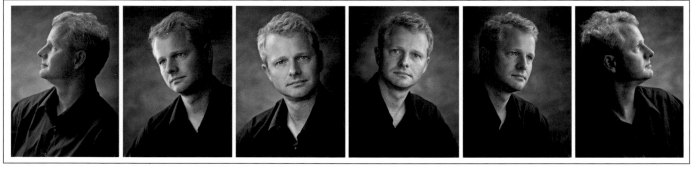

Shoulders are always at approximately a 45-degree angle to the camera for pictures using the basic pose.

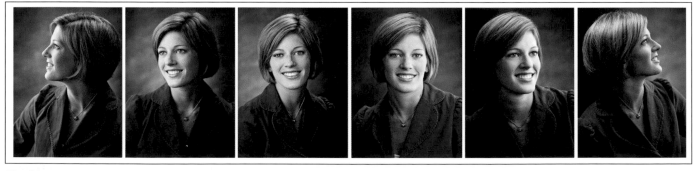

Shoulders are at approximately a 45-degree angle to the camera for most pictures using the feminine pose. The exception is the two-thirds closeup view, for which they are directly toward the camera.

Basic pose, full face.

Feminine pose, full face.

Basic pose, two-thirds view.

Feminine pose, two-thirds view.

Profiles always employ the feminine pose.

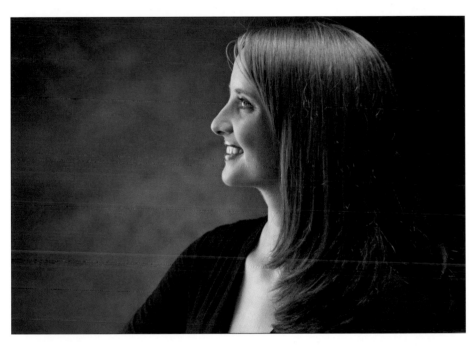

begins to show. When the head is turned too far the cord protrudes and distorts the neckline.)

2. The body is tipped forward at the waist, then leaned slightly in the opposite direction from the way the face is turned (*i.e.*, if the subject is looking toward the left shoulder, the body leans to the right).

3. The body faces away from the light source; the face turns back toward the light.

For the feminine pose, the position of the shoulders remains in a fixed relationship with the position of the head, regardless of the angle at which you are photographing the face. Therefore, once you pose and light someone in a feminine pose, you can leave the subject alone and simply move the camera position to photograph a full-face view, a two-thirds view, and a profile.

Because of this fixed relationship, the body faces directly toward the lens when the face is in a two-thirds view to the camera. This can make her look too heavy, so it's important to do one or more of the following:

1. Lean her body forward over the waistline and slightly in the oppo-site direction from which her head is turned. For example, if her head is turned toward her left shoulder, she should be leaning slightly forward and a little to her right. If she's looking toward her right shoulder, lean her forward and a little to her left. This will lower her shoulder in the direction that she's leaning. The slope of her shoulders is very important in maintaining a soft, feminine composition.

2. Unless the subject is *very* thin, crop the portrait above the bustline. If you crop lower, then you need to turn your subject's body slightly to the side, away from the light source..

As noted above, the only exception to the women-only rule with the feminine pose is when you are shooting a profile. Then, whether your subject is male or female, you will always use the feminine pose. This is because a face in pro-file needs the support of the body turned at an angle to the camera

Whether your subject is male or female, you will always use the feminine pose when cre-ating a profile.

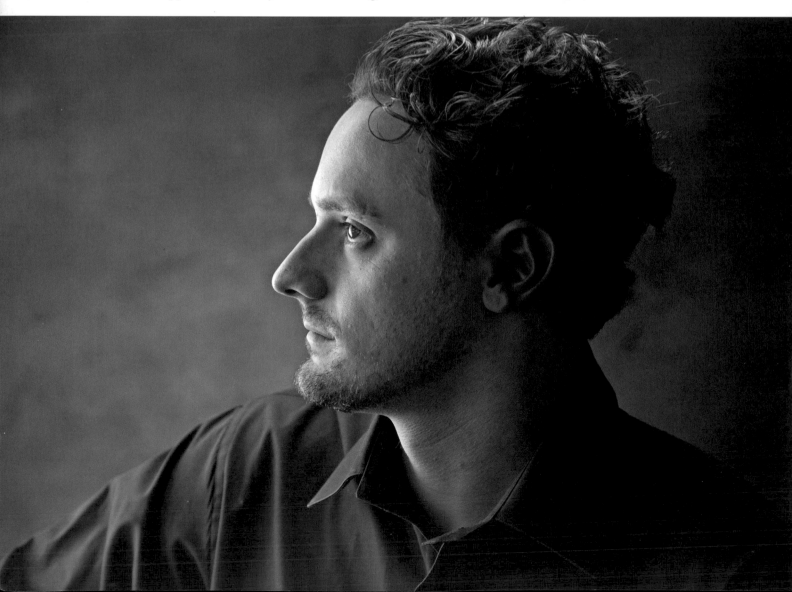

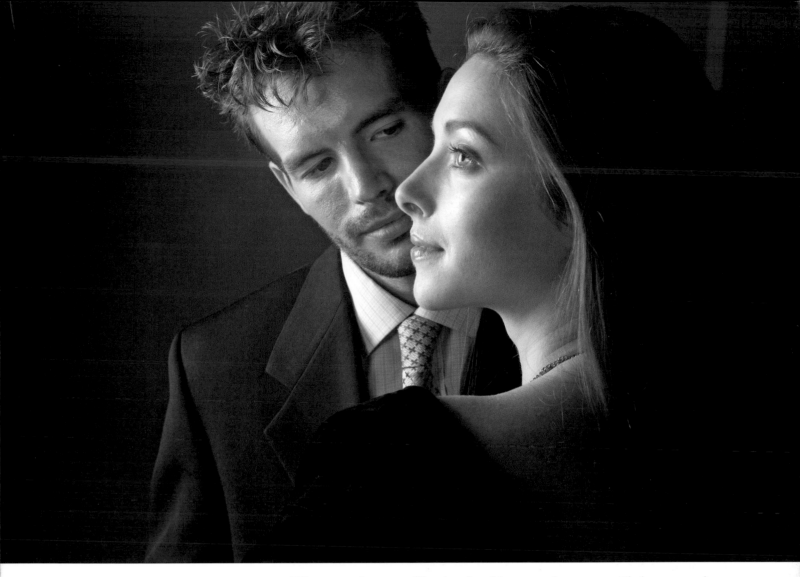

When photographing a back profile, you may need to soften the creases that appear on the subject's neck.

When creating a profile, the shoulders are always at a 45-degree angle to the camera. If you try to create a profile with the subject's body facing directly toward the camera or their back straight into the camera, you will produce a very strained appearance. I've seen this mistake made many times, and I want to spare your subjects the agony of twisting their neck more than necessary.

BACK POSES

In some cases, you may decide to photograph a subject with her back toward the camera. You can create a nice two-thirds view of a woman in the feminine pose by turning one shoulder directly toward the lens and then turning her face back toward that same shoulder; she will be looking back over her shoulder toward the camera. Be very careful doing this; you will be creating lots of creases in her neck that will have to be softened or removed later.

Occasionally, there will be a specific need to create a back profile—perhaps to show off a dress with a particularly beautiful back or when you want the train of a bridal gown to stretch out toward the lens. In this case, make certain that the body is still at a 45-degree angle to the camera. This also works well when you want to have two people facing toward each other. I would use a pose like this for a romantic image of a couple.

When you're creating a profile with the body toward the lens the lines in the neck are on the reverse side and do not show. When creating a back profile, on the other hand, you *will* show creases in the subject's neckline. These have to be softened in the finished portrait.

THE EYES

Undoubtedly, the strongest insight we have into a person's character is through his eyes. Direct eye contact—the subject looking straight into the lens—provides the most powerful connection between the subject and the viewer of the portrait. Unfortunately, this is not always practical, especially when photographing a two-thirds view of the face or a profile.

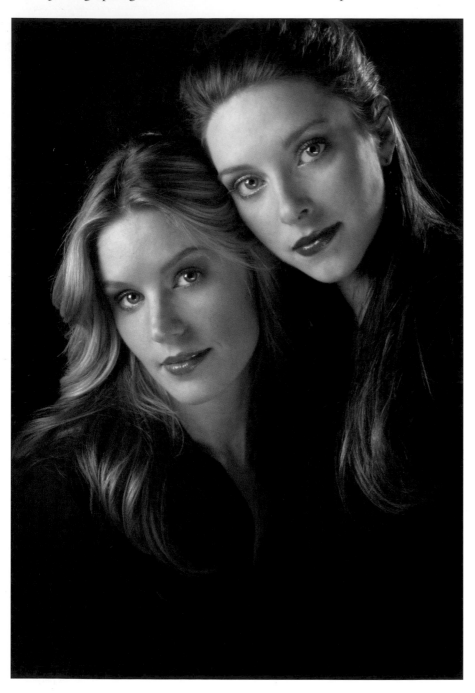

Direct eye contact (left) provides the most powerful contact between the subject and the viewer. When the eyes are directed off camera (facing), the image has a more subdued feel.

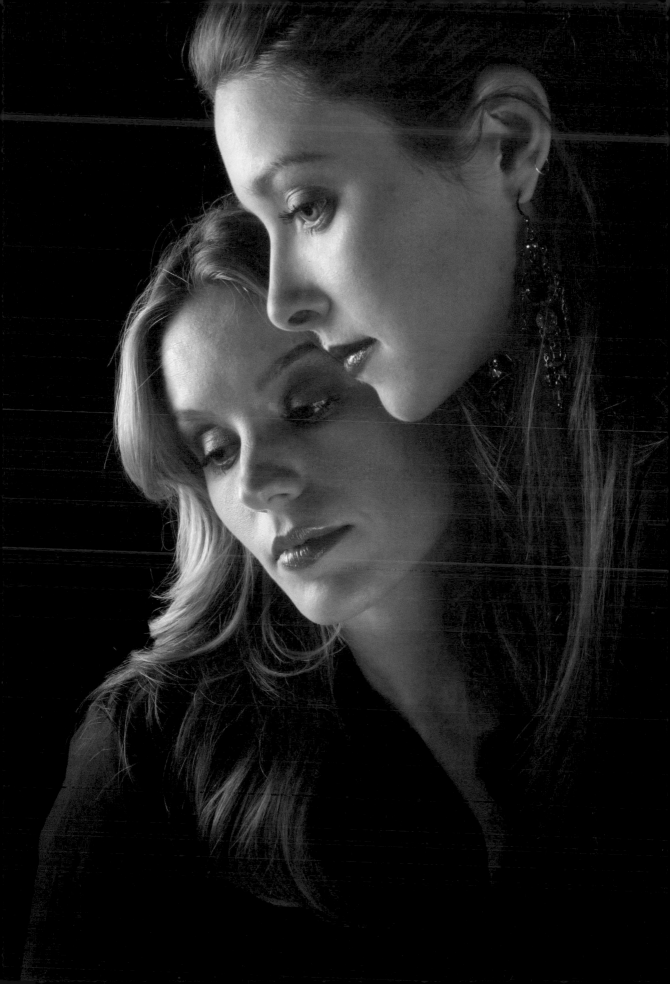

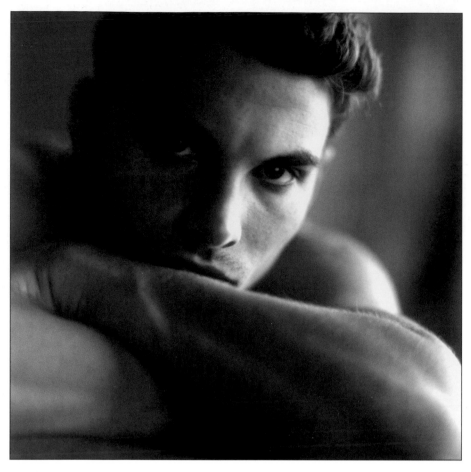

Also, I have often found that when people look directly into the lens their eyes appear to be slightly closed. When this happens, direct your subject to look at a point slightly above the lens. Often, their eyes will look much better if they're gazing at the top of your head rather than into the lens. There have been many occasions when I've had people looking even higher—yet, when viewed through the camera, they seem to be looking straight into the lens.

The eyes look best when centered in the eye sockets as seen from the camera position. This means that it doesn't matter where the subjects are actually looking. The important factor is that they *appear* to be looking where you want the eyes to be. Again, the only way to ascertain this is to establish the subject's eye position while you, yourself, are looking through your viewfinder.

Besides centering the eyes in the sockets, you should try to have the irises of the eyes just resting on the lower lids. When positioning a subject's eyes, I generally have them fix their eyes on a particular spot on the wall to give them a beginning point of reference. Then, if they are looking too high or too low, I can direct their eyes up, down, or to the side by simply asking the subject to look at a place a couple inches in one direction or another. (*Note:* It's a big mistake to have your subject look at your hand for eye placement; when you move your hand away, they no longer have a frame of reference to hold their eyes in that position.)

Try to have the irises of the eyes just resting on the lower lids.

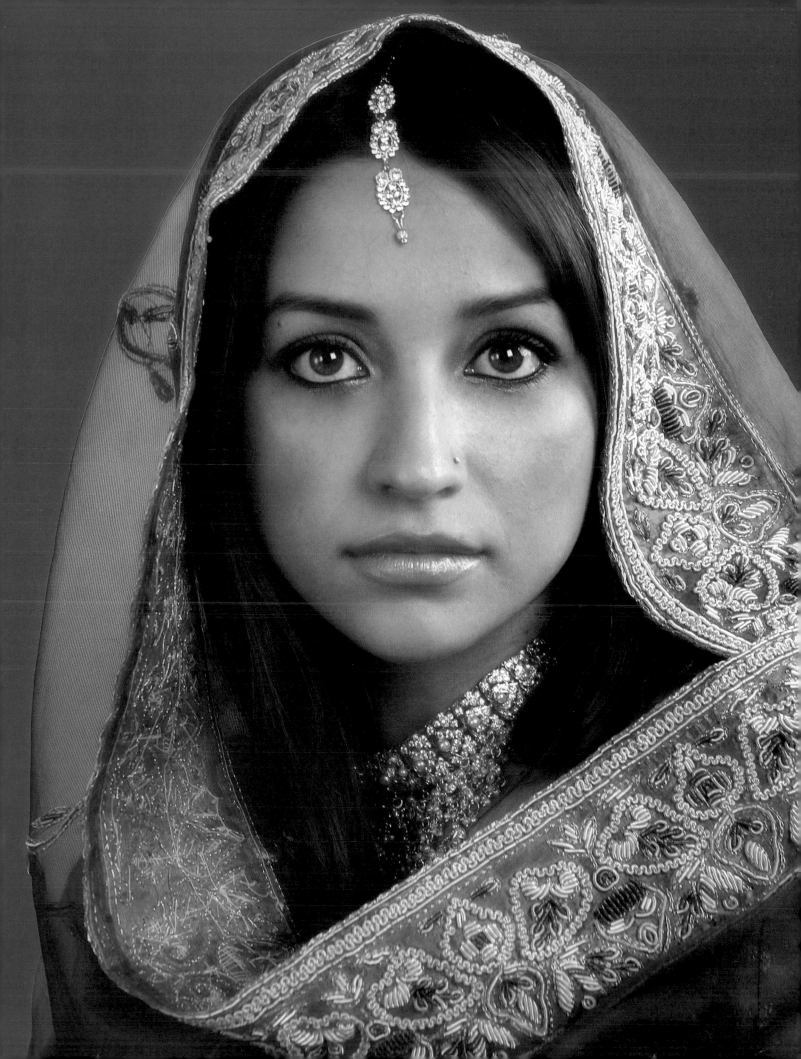

Occasionally, you may want to turn people's heads to a two-thirds view and have them look back at the camera. This can be effective with a female subject, but it rarely looks good for a man. What does one do, then, when creating an executive portrait where you think that the subject should be looking directly at the camera, but you know that you can get a more flattering picture of the person with a two-thirds view of the face? I simply say to the subject, "Is it more important that you be looking into the lens for your portrait or that I photograph the most flattering angle of your face?" That usually settles the problem—but you may still want to do a few pictures of the full face to cover your bases!

Whatever you do, get light into your subjects' eyes. If they have deep set eyes it's sometimes necessary to lower your main light or raise their faces to get the light into their eyes. More on this in chapter 7.

EXPRESSION

The one *critical* thing that I haven't discussed here is the expression—the most lasting part of every portrait. You can have flawless posing and lighting, but if you don't have a good expression, the photograph just won't make it.

It's usually a good idea to ask your subjects whether they prefer themselves to be smiling or more serious in a portrait. Many people don't look good smiling. A more serious expression is usually more comfortable and generally creates fewer problems later on when the image selection is being made. Serious portraits also seem to last longer.

If you feel that the subject will look better with a smile, then by all means go for it. For the most part, I usually ask for a slight suggestion of a smile, but not a complete smile—especially if it appears to be a forced smile.

For "big smile" images, watch the expression carefully—there's nothing worse than an artificial smile. Some

With female subjects, you can create an effective image by posing her face in a two-thirds view and having her look back at the camera.

So, what would you have done in this case? Asked for more of a smile or shoot when I did? This photograph is one of my favorites. Once in a lifetime do you catch something this fun!

people may give you a very unnatural grin with their lips together, or a smile with only a small part of the upper row of teeth showing. I always force my subjects to show that whole upper row of teeth, when they're creating a "big smile" image. Anything less than that usually looks very artificial. My favorite prompt is to say, "Teeth!" and keep repeating it until I see that whole upper row of teeth shine through.

"Smile with your eyes!" is a good prompt to have up your sleeve. When they do that, they usually forget about their mouth—and that's usually when I get the most natural expression. If a natural smile doesn't surface I'll say, "Ooh! That looks terrible!" This usually bring a more pleasing expression.

POSING TOOLS
Posing Stools. I can't think of anything more important to have with you at all times than a pair of posing stools. They allow you to adjust the heights of your subjects' heads within seconds.

This is useful for both single-subject and group portraits; with the use of two good posing stools, you can easily compose a portrait of two, three, or

four people. A good posing stool will range in height from 20 to 30 inches. A posing stool that goes up to at least 30 inches will allow you to seat one person and have a second person stand beside the stool. This will bring the subjects' heads to a similar height, so the standing person will not have to bend over to position the subjects' heads close together. If there is too much of a difference between the seated and the standing person, the taller person will look and feel very uncomfortable when you try to bring them together.

There are many posing stools on the market. The deciding factors on which ones to get are the ease of adjustment and whether they have a wide range of adjustable heights.

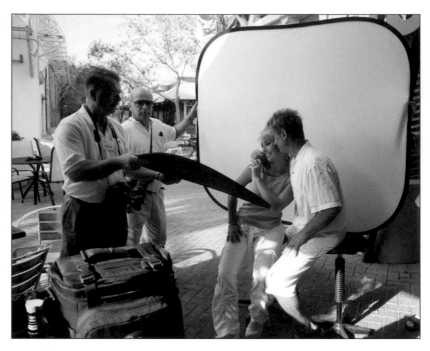

Whether in the studio or on location, posing stools make it easier to execute your shoot.

Posing Tables. To create a good base for a head-and-shoulders portrait you can place a posing table directly in front of the subject, who should be seated at an angle to the camera (as described on pages 32–34).

The height of the table should be adjusted to the level where the back shoulder (the shoulder that is turned away from the camera) will be lowered slightly when the subject leans forward. In the absence of a posing table, another posing stool can be used. The important principle here is that the prop be at the correct height to lower the back shoulder.

With the table in place, have the subject reach out the arm farthest from camera position and place his elbow on that table. Bend the arm so that the elbow is extended and the hand comes back toward the body—I tell people to bring the elbow out and reach the hand back as if they were scratching their tummy. It's silly, but it helps them remember. When the arm is in this position, it forms a good base for the composition. (*Note:* Many photographers pull the front arm forward toward the camera instead of extending the back arm out to the side. This creates a large front shoulder and a much smaller back shoulder; everything is out of proportion.)

FINAL ADJUSTMENTS

I've usually found that, once your subjects have been posed, it's better to refine the posing by simply speaking to them from camera position rather than approaching them time and again to make adjustments. These minor adjustments can usually be made verbally or by using simple hand signals. Touching the subject too much can make the person very uncomfortable—besides, you really need to be looking through the viewfinder when you're making these refinements. This is a good reason to shoot from a tripod whenever possible.

5. GROUP PORTRAITS

B ringing multiple people together in one image means posing them so that they each look good individually and so that the combined unit looks good together. Each person in the picture is going to look at themselves first—individually—when viewing the picture. So, before making the exposure, look to see that each person looks good. Pretend that each of them is the only person in the picture. Does he or she look as good as possible? If not, make the needed changes.

In this chapter, we'll focus on posing the smallest of groups: two people. However, the basic guidelines apply to groups of other sizes.

When posing multiple people, everyone in the image must look good. Here, the pose captures a fun moment.

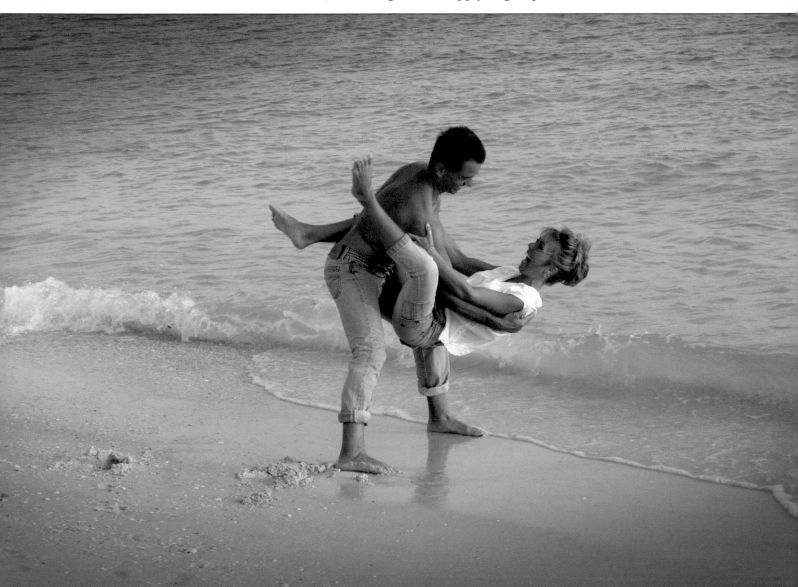

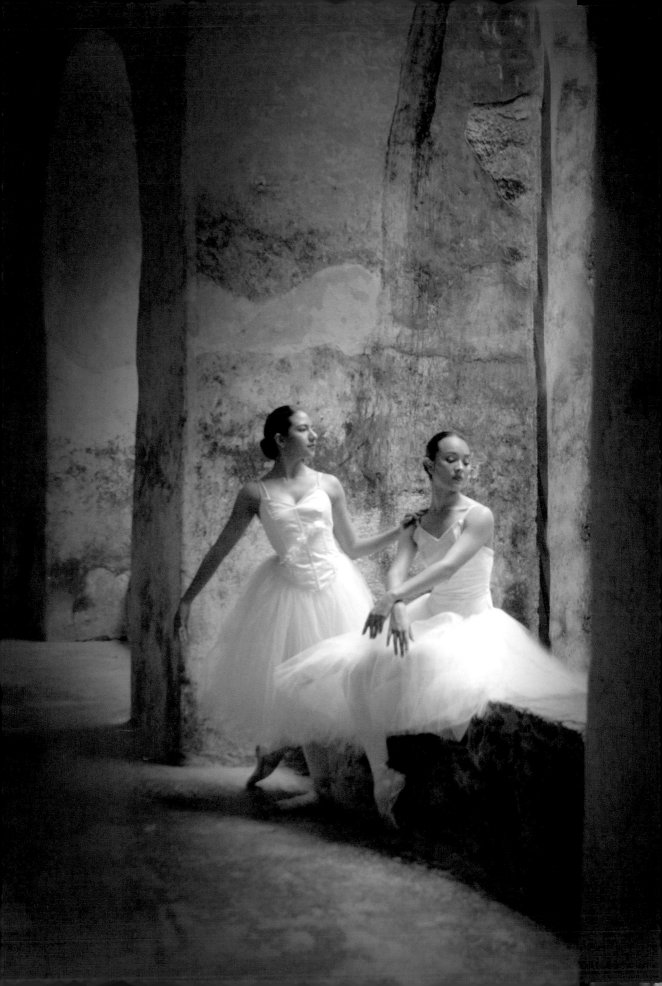

FACING PAGE—Group portraits can also be made with activity-oriented poses, like dancing, walking on the beach, or even just having fun in a park.

POSING STRATEGY

Do you pose one person first and then bring the second person into the frame? I wouldn't; it's a waste of time. It's a much better idea to bring the group together and then refine each of them in position with the other person. Otherwise, you may spend a lot of time refining a person's pose, only to find that you have to change it after adding the second person. With a larger number of people, bring the entire group together before refining each individual person. Look at what you're doing through the viewfinder of your camera as you make each adjustment. That way, you won't be making additional problems for yourself as you finalize each of the poses.

In some cases, an unconventional posing strategy can produce an interesting portrait.

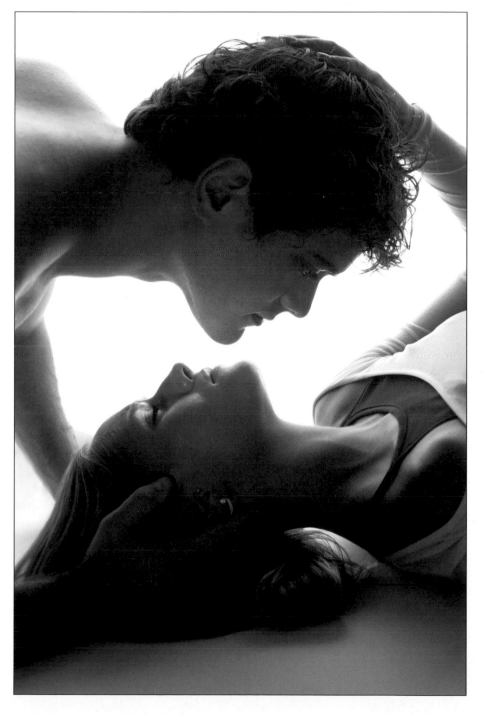

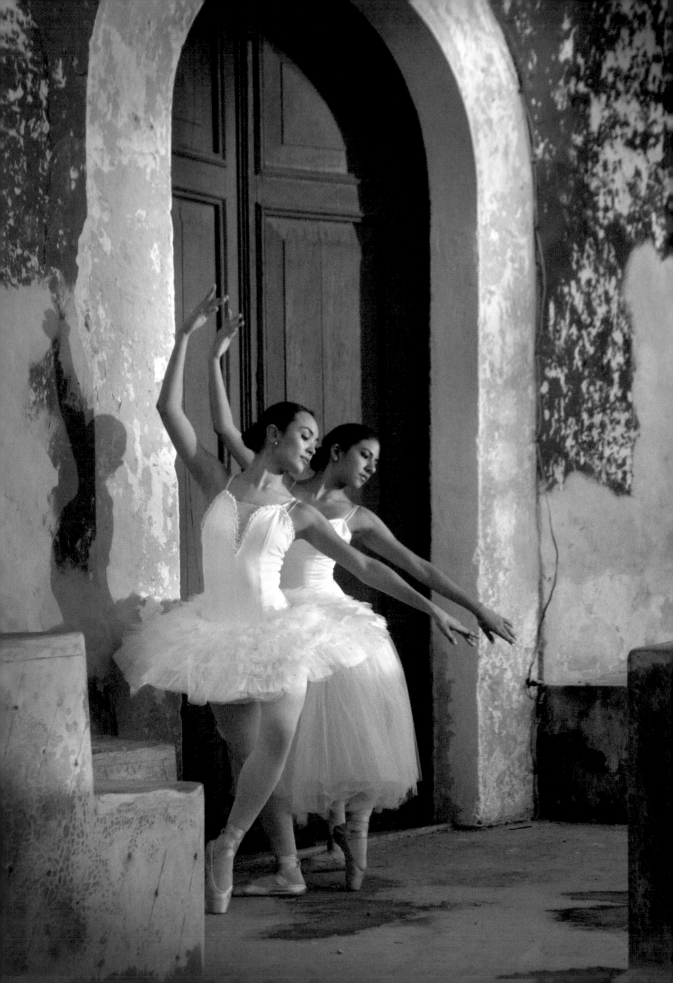

SEATING

Without stools you're fighting a losing battle—you're just making your life more difficult. Do I take posing stools with me for outdoor portraits? Of course I do! It's certainly better than trying to make do without them. If you don't have posing stools, seat one person in a chair. Then, bring over an armchair and have the second person sit on the arm of the second chair. That will usually work.

For a simple portrait of two people, set up two posing stools. Then, tell your subjects not to move the stools but to sit down on the edges of them. Each subject should keep the foot farthest from the camera set solidly on the floor, so that they will be able to lean forward toward the other person.

FACING PAGE—Here, the two dancers are positioned with their bodies both facing in the same direction.

BELOW—In this full-length portrait, the couple is posed facing each other and with their heads each tipped slightly in toward the center of the frame.

DIRECTION

Next, determine what direction the bodies should be facing. There are two options: you can bring them together with their bodies facing toward each other, or you can put them together with their bodies both facing the same direction.

Facing Each Other. When you are facing the subjects toward each other they should start out with their stools at least a foot apart (for heavier people, start with the stools a bit father apart). This allows them room to lean their bodies over their waistline and toward each other.

Begin with your subject's bodies slightly apart and angled toward each other. Make sure that one person's shoulder doesn't go perpendicularly in the other person's chest. When the bodies come together at right angles, you're in an impossible situation; there's no way that you'll be able to bring their heads together naturally. Placing the shorter person's shoulder under the armpit of the taller person is a good starting point for being able to bring the two heads together comfortably. Do not, however, ask the shorter person to put their arm around the taller person. That will usually pull the shorter person's body

There are two options when posing two people: you can bring them together with their bodies facing each other (left), or you can put them together with their bodies facing the same direction (facing page).

around too much and angle their shoulder too directly into the lens of your camera.

With the subjects' bodies in the correct position, have them lean forward at the waist, bringing their heads together without their bodies getting in the way. When creating extreme close-ups of people in an emotionally involved situation it usually works well to have their lips very close together, almost touching.

Facing the Same Direction. The second way to bring them together is with their bodies both facing in the same direction. When posing two people

this way, the posing stools should be directly next to each other, allowing both people to lean forward toward their knees. In a pose like this, I've seen some photographers have the person in front actually lean *back* to get the heads close together. It never looks good for someone to lean back in a picture. That's why the stools need to be together; when the front person leans forward, the second person needs to be able to lean forward, too—and still get their heads together.

Of course, you need to plan all of this *before* you ask your subjects to sit. Then, tell them exactly what they should do. This instills confidence; your subjects will feel sure that you know exactly what to do. You might even tell

When posing two people facing the same way, the posing stools should be directly next to each other, allowing both people to lean forward.

them in advance that they may not feel exactly comfortable—but, take your word for it, it will be the most flattering portrait that they have ever had of themselves. Explain that a comfortable pose may look very sloppy, but a pose where they are sitting up and leaning forward will help them look their very best. They'll cooperate with you!

HEAD HEIGHT

Adjust the position of your subjects so their heads are not at the same height. You should never start with heads more than a half of a head apart in height. If you begin with heads farther apart than that, the taller person will have to bend over too much or stoop over uncomfortably to bring them together.

A general guideline is to have the taller person's mouth at the level of the shorter person's eyes. When composing portraits horizontally, you may want to use a slightly smaller height difference so that the shorter person does not appear to be falling out of the bottom of the portrait.

Again, height adjustments are definitely made much easier with the use of a couple of posing stools. With them, it's a simple task to raise or lower each of the subjects to achieve the desirable relationship.

ABOVE—Posing the eyes of the shorter person at roughly the mouth of the taller person creates an appropriate variation in head height.

FACING PAGE—When creating extreme close-ups of people in an emotionally involved situation it usually works well to have their lips very close together, almost touching.

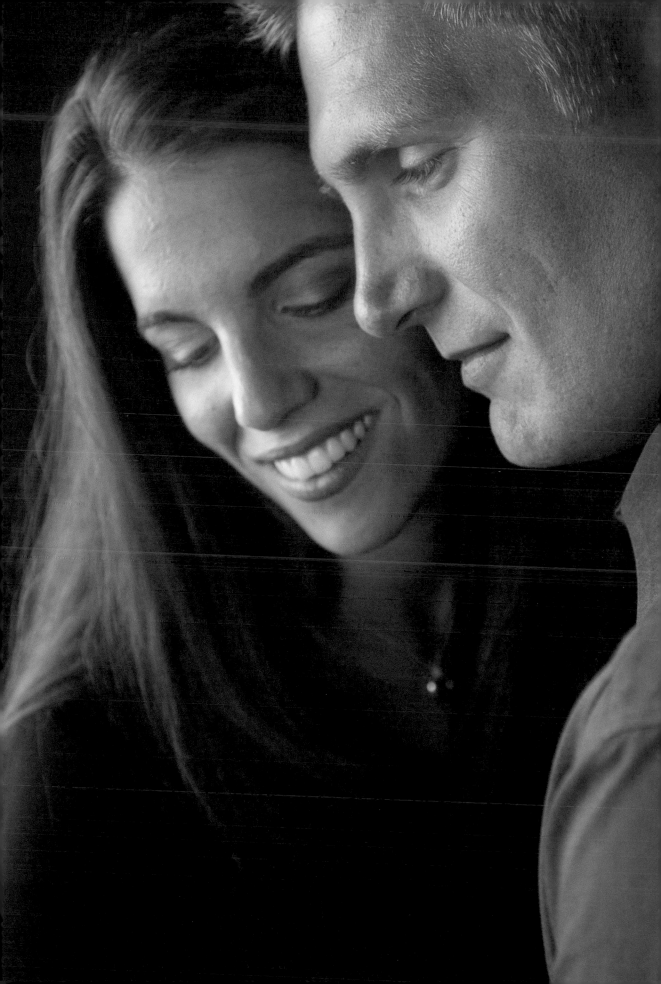

6. LIGHTING EQUIPMENT

I've found that it's easier to have *all* the necessary tools with me *all* the time than it is to have a lighter load and wish that I had something to help me through the problem situations that seem to arise with just about every portrait sitting. Photographers who want to "lighten" their load by not carrying the necessary items always seem to end up actually doubling their workload, because they don't have what's needed to make their life easier.

BUYING LIGHTING EQUIPMENT

Although you can probably use any equipment on the market and get good results, I think it much better to get suggestions from a qualified photogra-

When you're using a complete system for lighting, you have total control of everything from start to finish.

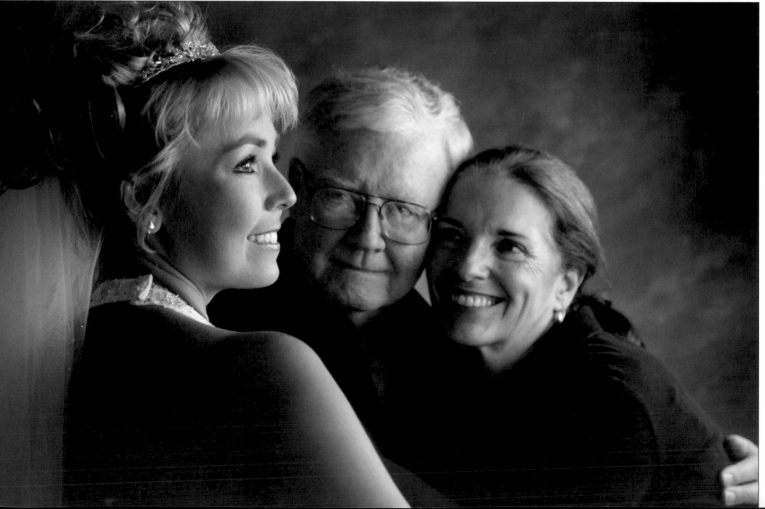

A basic studio lighting setup with two West-cott Mini-Apollos.

pher instead of a store salesperson. You want to get equipment that you will not outgrow as your needs become more specific. My personal experience is limited to the two lighting manufacturers that I have been using since I went from flashbulbs to strobe. All my flash portrait lighting equipment is made by Photogenic. The lights that I've been using more recently are the Spiderlites by Westcott. I'll explain both in detail.

STUDIO FLASH

Relying on available/ambient light (window light, etc.) is much more difficult than working with lights that you can control. It took me a long time to re-alize that. When you're using a complete system for lighting, you have total control of everything from start to finish.

What to Look For. If you're going in for a flash system, you should en-sure that the lights will be practical for your uses. Here are a few things to consider:

1. Consider the power of the flash units' built-in modeling lights; they need to be bright enough that you can see the light patterns that you're creating with them. Many flash systems have such weak modeling lights it's almost impossible to know in advance what you're doing.

2. In some cases, flashes are much too powerful for simple portraiture. You don't need a *lot* of power for portraiture. Therefore, you should select a lighting system based on its ease of use and its practicality, rather than the power of the flash it puts out.

3. Flashes can be very heavy, making them difficult to transport, set up, and use. Large, heavy lights could be very impractical. They also make it very difficult to put a hair light on a boom stand.

4. Look for versatility. If the same lights you use for portraiture can also be used for lighting an entire reception room, you've got a double-whammy. That's exactly what I found when I developed the Photogenic lighting system: two of the lights that I use for my portraits double perfectly for lighting the room for my candids at wedding receptions. This is covered in greater detail below.

My Studio Setup. My favorite flashes for portraits is the PhotoMaster™ II VoltageSmart™ Light System by Photogenic. This system has four Photo-

My basic studio setup consists of four Photogenic lights.

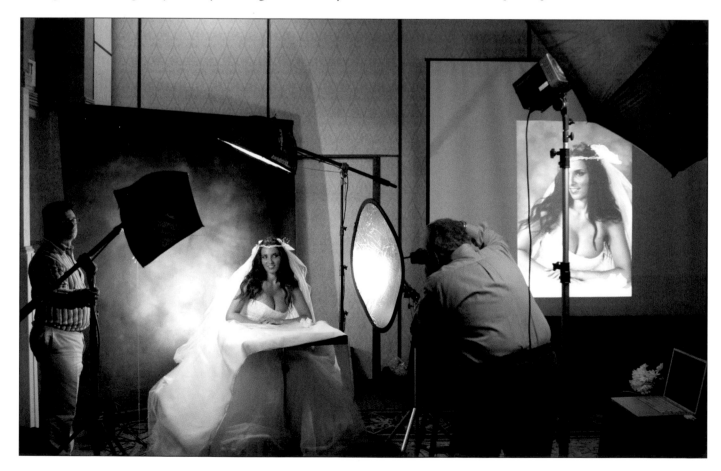

Here you see my basic studio setup in use to photography a bridal portrait.

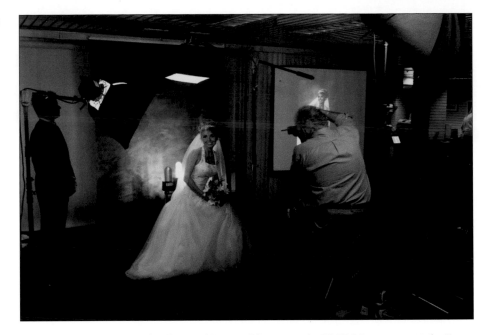

The heads are virtually weightless, which is perfect for the way that I use them.

genic PA8C light heads plugged into a Photogenic PM800 power pack. I use a Photogenic PowerLight™ PL1250DRC monolight as my fill. I prefer this system over all others because I know that it fills all my needs. I also know that, regardless of my needs, I will never outgrow it. Additionally, the light heads are small and fit easily into my softboxes. The heads are also virtually weightless, which is perfect for the way that I use them.

Here's my basic setup. I plug two PA8C heads into the power pack and position one on each side of my subject area. Each light is placed in a Westcott Mini-Apollo, a 16-inch square light modifier with a translucent front and sides that are black on the outside but silver on the inside. I like these small light sources, because they allow the light to spread evenly over as many as five people, yet they can also be directed so that the fall-off is only one stop from the face to the floor. The two PA8C lights are both placed on Westcott boom arms, allowing me to position them anywhere without having to worry about getting the light stands into my pictures. With these lights flanking the set, I can turn my subjects in either direction and always have my lights in place without having to move them from side to side—one of the two lights is simply used as the main light, while the other becomes a hair light.

I have an additional two PA8C lights behind my subject. Both of these also plug into the Photogenic PM800 power pack as the main and fill lights. One is used to light the background. The other becomes either a backlight for a bridal veil or a kicker light to highlight the edge of a subject's face. A fifth light, the Photogenic PowerLight™ PL1250DRC, is a self-contained strobe light that has its power pack built in. This is placed behind me while I am photographing. It sits high on a tall light stand and is bounceed into an umbrella to create the fill light.

We'll address lighting techniques in greater detail in the next chapter, but here's the basic strategy for this setup. The main light establishes the exposure, and the fill light is set two stops less. I adjust the intensity of the hair

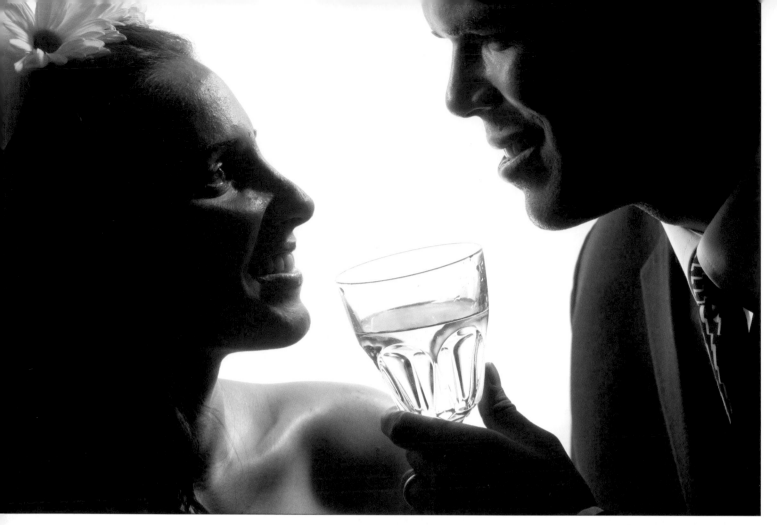

To make the background lighter or darker than it is, more or less light can be used on it. Here, it's rendered pure white.

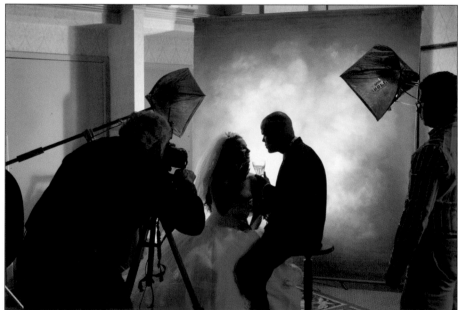

light according to the color of the hair—more for dark hair and less for light. When the hair light is placed, most of it is actually falling on the floor behind the subject. Otherwise, it would be too strong and overexpose the hair. If I want the background to be the tone that it actually is, I'll have the same amount of light on the background as on my subject. To make the background lighter or darker than it is, more or less light can be used on it. The light I mentioned using for backlighting a bride's veil is set almost as weak as I can get it. Too much light so close to the veil would overexpose it so much that all the detail would be lost.

A Secondary Use. The secondary use for these Photogenic lights is to employ two of the larger heads to light the dance floor for reception pictures. Photogenic makes Fresnel lenses that fit over the light heads. With these in

place, the lights create a starburst effect when they get into candid pictures. Without the covering the lights could flare the lens when you're shooting directly into them. I place one light on each side of the dance floor and set the power to match the aperture at which I'm shooting. That way, the entire dance floor is lit up—it's pretty much the same as photographing outdoors.

CONTINUOUS FLUORESCENT

One of my favorite recent discoveries is the use of fluorescent lights; I use Westcott's Spiderlites. If you like making portraits by window light, you'll love these—they're just like windows, except that they're *always* available and can be moved to whichever side you want them to be on. Because they are

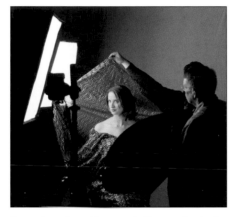

One of my favorite recent discoveries is the use of fluorescent lights. I started using only two lights (in softboxes) and a reflector, as seen in this image.

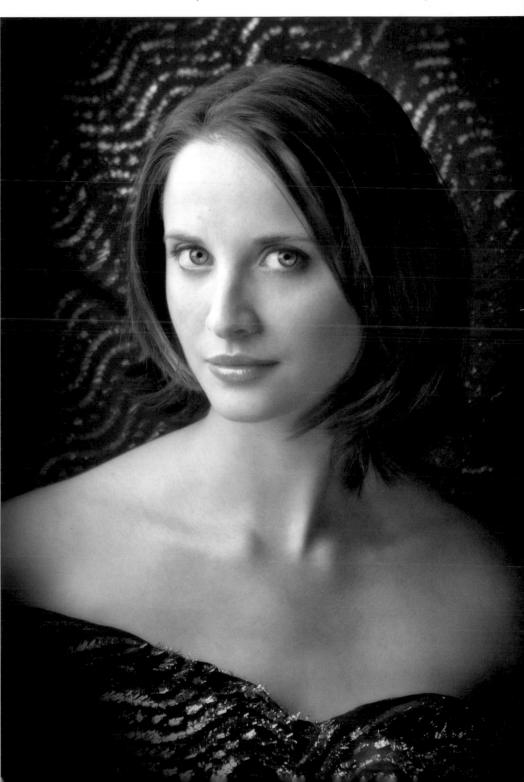

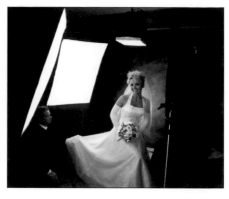

While the two-light system was a great place to start, I soon found that it lacked flexibility, so I started using a four-light system for maximum control.

continuous sources (they stay on all the time rather than flashing), they are great for children, who are sometimes scared by flash. Additionally, the lights are not hot, yet they're bright enough to contract your subjects' pupils, showing more of the eye color than is possible with the modeling lights on most flashes.

I started using only two lights (in softboxes) and a reflector. I keep both lights on the same side of my subject. The main light is placed at approximately a 45-degree angle to the face, while the second light is placed where you would normally place a profile light. The light from the setup is so beautiful and easy to work with, you'll probably never touch window light again! I've lit everything from extreme close-ups of a single face to a group of fifteen with a single one of these lights.

While the two-light system was a great place to start, I soon found that I missed the flexibility of the five lights I was used to with flash. I started using a four-light Spiderlite system for maximum control. Two of the lights are five-bulb TD5 models with large, 48x32-inch softboxes. One of these is the main light and the other is placed behind the camera at a 45-degree angle to highlight the edge of the subject's face. I refer to this light as a "kicker" light, because it creates the specular highlights on the subject's face that give it depth. I also use two other lights, both of them three-bulb TD3 models. One is on a short stand just off the floor and is used to light the background. The other is on a Westcott boom arm with a small softbox and is used as a hair light. Optionally, you can add a fifth light and use it as a fill behind the camera, just like with the flash system. When I do that, I use a five-bulb D5 with the large softbox placed behind me while I am photographing.

When working with the Spiderlites, you expose with just the existing light from the fluorescent tubes. I usually shoot in the aperture-priority mode with my ISO set anywhere from 400 to 800 so that I can hand-hold the camera when necessary. After viewing my initial exposure, I adjust as needed. For example, when I'm photographing dark clothing against a dark background, the aperture-priority setting is going to overexpose the skin tones. Conversely, if I'm exposing for light clothes against a light background the skin tones will more than likely go a little darker than I want them to be. On most of today's digital cameras, compensating for this requires only a simple adjustment.

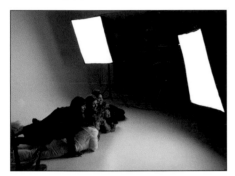

Two softboxes on Spiderlites flank the set for a fun family portrait.

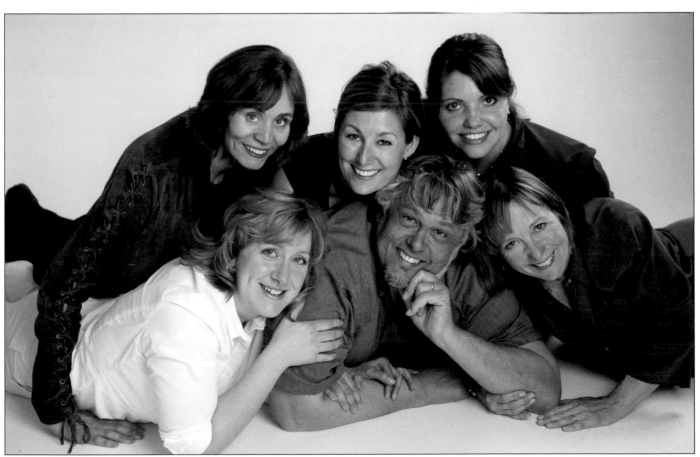

7. LIGHTING TECHNIQUES

Light should be used to draw the viewer's attention to the main subject in an image. It should make the subject appear three-dimensional. At the same time, it should make the subject stand out from the background. When looking at a portrait, it should seem as though you could almost step right into the photograph—even walk behind the subject. Hence, a very dark background (with no separation between it and the subject) usually doesn't work well.

Good lighting is almost invisible. It shows the subject to great effect without calling attention to itself.

Good lighting doesn't have to be complex; in fact, it's often very simple to achieve.

Like good posing, good lighting is almost invisible—it is a means to an end, making a statement about the subject in the portrait without calling attention to itself. Poor lighting, on the other hand, is conspicuous and distracts the viewer from the subject.

Lighting should be simple and it should be easy to achieve. Concern for the technical aspects of creating a photograph should never outweigh the attention you pay to creating the best possible image of your subject. In order to keep lighting simple, however, you must develop the technical abilities that allow you to produce a good digital file.

MAIN LIGHT

Distance to Subject. I keep my main light about three feet from my subjects. Keeping your lights the same distance from your subject all the time is a good habit to develop. If you don't, you're going to have to constantly take exposure readings to prevent your exposure from being all over the place. This is a waste of time and takes your attention away from the subject.

Which Side of the Subject? On which side of the subject should the main light be placed? Think about this for a moment. You certainly don't want to start lighting from one side and then find that you have to move the main light to the other side when you switch from a full-face to a two-thirds view.

Learn to plan in advance. You will always want to turn the subject's face toward the light, so decide what direction this is, then position the main light on that side before you even have your subject sit down.

Some photographers are in the very bad habit of always working with their main light on the same side. This, of course, means that you're breaking every guideline of using facial analysis to achieve the most effective portrait of each of your individual subjects. You definitely want to turn the face of your subjects toward the light—but you can't do that if your facial analysis tells you to turn the face in the opposite direction from where your main light is permanently placed! If you're there already, break the habit immediately; if you're just beginning, don't even *think* of always keeping the main light on the same side.

Full Face, Basic Pose. For a full-face portrait of a person in the basic pose, it's possible to bring the light in from either side—but if you're later going to change the face to a two-thirds view, you should place the light on the side toward which you'll be turning the face. By planning ahead you'll avoid having to move the light from one side to the other after you've begun the portrait sitting.

Don't fall into the bad habit of always having the main light on the same side of your subject. Where it is placed should be determined based on facial analysis, not habit!

Full Face, Feminine Pose. For a full-face portrait of a person in the feminine pose, turn her body away from the light and then turn her face back to the light. Remember that you'll always be positioning the main light so that the shadowed side of the face is toward the lens.

Two-Thirds View or Profile. When turning a face to a two-thirds view or profile, place the light on the side toward which the face is turned. This enables you to light the front of the person's face instead of the side that's closest to the camera. Again, you want the shadowed side of the face toward the lens.

I know of all kinds of light patterns, but I use only one: a "modified loop."

Consider the Nose. If your facial analysis has revealed that you need to make your subject's nose appear straighter, position the main light so that the shadow is against the straighter side of the nose. Bring the "problem area" into the light and show off the straighter side against the shadow.

The One and Only Lighting Pattern I Use. This is the most important section that you can read, learn, and master. If you stick to what I'm telling you here, you'll be able to use this information for the rest of your photographic career—yes, it's *that* important!

I know of all kinds of light patterns, but I use only one. It serves me well for all of my portraits. The name for this light pattern (if you need one) is called a "modified loop." Rather than looking for the loop, however, I'm more concerned with the light on the side of the nose. When that's correct, you can be pretty sure that you've got it right.

To create this pattern, I begin by looking for light in both of my subject's eyes. To create this, the main light is placed slightly above the subject's eye level and at about a 45-degree angle to the face. From that position, the light creates a shadow on the side of the nose. This runs from the bridge of the nose down to

the base of the nose where it produces a small loop-shaped shadow. This shadow should not extend down so low that it touches the lip line.

The most common problems with creating this lighting pattern (and their solutions) are as follows:

1. When the shadow goes beyond the base of the nose and begins crossing over the cheek, it's because the main light is too far to the side, or because you've turned the face too far away from the main light.
2. If the face is turned too directly into the main light, the lighting effect becomes flat; there are no shadows to create the impression of depth.
3. When you see light on the ear of the shadowed side of the face it's because the light is too close to the front of the face. Either move the light further to the side or turn the face away from the light until you achieve the lighting pattern that I've described above.

It all seems so simple—and it is! Once you've "seen the light" and can use it properly, you're on your way. There's nothing difficult about it. You just have to stick to it and accept nothing else.

Emphasizing Detail. When you need to emphasize detail in a person's clothing, you will pick up more texture when the light crosses over the body.

Turning the bride's body away from the main light emphasizes the texture of her gown.

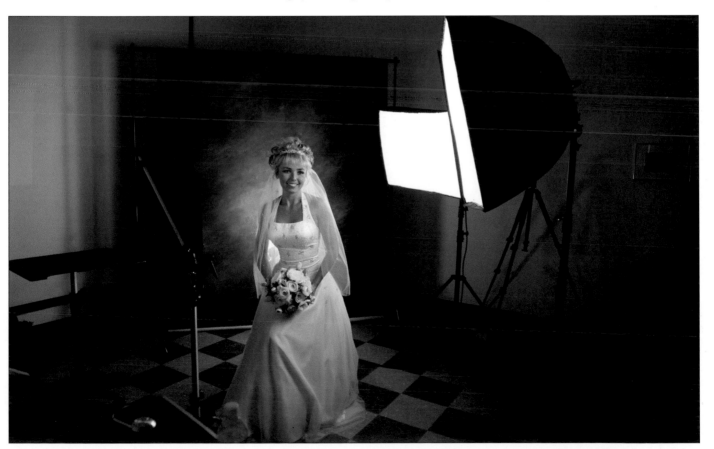

For example, to bring out more detail in a wedding gown, you should turn the bride's body away from the main light source. This is exactly what you see in the feminine pose, which makes it ideal for bridal portraiture; it produces a graceful look while bringing out the texture in the gown.

When a person is in the basic pose with their body facing toward the main light, you can still bring out detail in the clothing if you carefully use an additional light source from the profile position (at a 45-degree angle behind the subject). This will emphasize the clothing and create great highlights on the face at the same time. The two lights should be of equal intensity.

Placing the reflector in front and slightly to the side of the subject's face will open up the shadows created by the main light.

REFLECTORS

What's the secret about placing a reflector? It's no secret. It's common sense—just ask yourself the *purpose* of the reflector.

Reflector for Fill. If the light pattern on your subject's face is exactly the way you want it to be and you're just looking to open up the shadows slightly so that the portrait will have good detail throughout the face, then you place the reflector on the shadowed side of the face.

Do not, however, place the reflector *beside* the subject's face. If the reflector is beside the face it will bring in light from a second direction and create cross-lighting. The proper placement for a reflector that is meant to open up shadows is in front and slightly to the side of the subject's face. That way, when the main light hits the reflector, the reflector bounces the light around onto the shadowed side of the face, keeping everything looking as if all the light is coming from a single light source. (*Note:* Of course, the main light source must hit the reflector. If you don't turn the reflector toward the light source—and if you don't turn the light source so that some of the light is hitting the reflector—it's not going to do you any good!)

Reflector as a Secondary Main Light. A reflector can also be used as a secondary main light source. It's like using two main lights in a studio environment—but it can also be used with window light or outdoor lighting. Here's how it works.

Light one half of your subject's face with your main light source (creating a split-light pattern). The opposite side of the face will have no light at all. You can even turn your subject's face slightly *away* from the main light, so the light skims along the side of your subject's face and the bridge of the nose.

Then, place a reflector on the same side of the subject as the first light. Position the reflector exactly where you would normally place your main light, getting light into both eyes and shaping the face with the same modified loop light pattern discussed above. To do this, turn the reflector toward the main light so that it will pick up the light. Then, rotate the reflector gradually toward the subject until it bounces the light where you want it.

If you don't turn the reflector toward the light it won't do you any good!

8. WINDOW LIGHTING

One of the most popular choices for indoor lighting is window light. It's available for a good part of the day and it's cheap. When you've got indirect sunlight through the window, it's also easy to work with. Even with direct sunlight, a simple translucent scrim, such as the Westcott 1707, can make it useable for portraiture. The key to successful window lighting is that you want to achieve the same lighting patterns as you would when creating a studio portrait.

FACING PAGE—When you know what you're doing, window light can create a dramatic impact.

BELOW—Sometimes it works to show the window itself in your image. This can be a distraction, though, so you should use the setup judiciously.

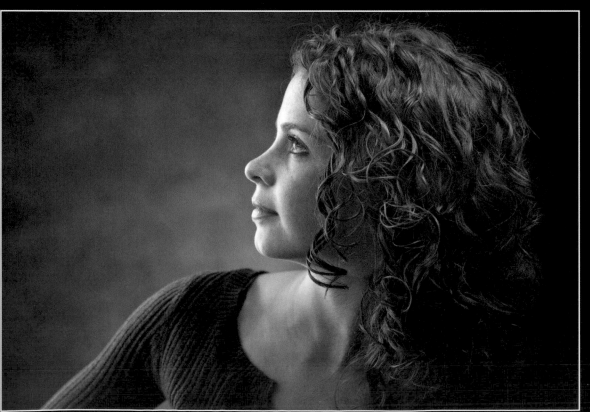

TOP LEFT—To create a full-face view, the camera is next to the wall with the window.

TOP RIGHT—To create a two-thirds view, the camera moves further out into the room.

LEFT—For a profile, move the camera even further into the room. For all these views, the subject never moves; the camera is simply repositioned. The background has been muted, however, by repositioning the camera.

DIRECTION OF THE WINDOW

When photographers first began creating daylight portraits, they favored north light as their main light source. That's because a north-facing window gets no direct sunlight and is usable most of the day. Of course, if you live in the southern hemisphere, you need to go to a window with a southern exposure.

COMMON PITFALLS

Height of the Light Source. There are several pitfalls with using window light. One of them is the height of the light source. As we discussed in a previous chapter, good portrait lighting should come from above the eye level of the subject. You might think that this would not be a problem with light coming through a window, but quite often the light is not coming from the sky. Often, it's bouncing off a building or off the sidewalk outside. This means the light will be coming up from below the subject. That's not good at all; the more powerful light will miss your subject's face and concentrate on the lower part of their body.

When you see this happening, you need to seat your subject so that the predominant amount of light is hitting their face with a slight fall-off toward the lower part of their body. Alternately, you can cover the bottom of the window and hope that the light coming in over top of that obstruction will be more appropriate. Better yet, find a different window.

Window Treatments. Another thing to be aware of is window treatments that cover the top of the opening and force most of the light to come in from below. If you're standing your subject near a window like this, the strongest light will be on the bottom of that person, missing the face. Not good! To correct that problem, you would need to seat your subject so that the strongest light illuminates their face.

Showing the Window. Many photographers who use window light show the window in all of their photographs. For the most part, I find the windows to be a distraction. Certainly, you wouldn't want to get your portrait lights in a photograph, would you? I can see including the window in a portrait from time to time, but not in every image.

DISTANCE OF WINDOW TO SUBJECT

If you keep your subjects a short distance from the window, you'll find that the light wraps around them more beautifully and with much less contrast than when they're very close to the window. Therefore, I've found it best to work a few feet from the window. With digital cameras, it's easy to increase your ISO setting to 600, 800, or 1000 without degrading the photograph, so the drop in light intensity shouldn't be a big problem.

CAMERA AND SUBJECT POSITIONS

One of the biggest problems photographers have with window lighting is knowing where to stand when setting up for the portrait, and how to change

> Good portrait lighting should come from above the eye level of the subject.

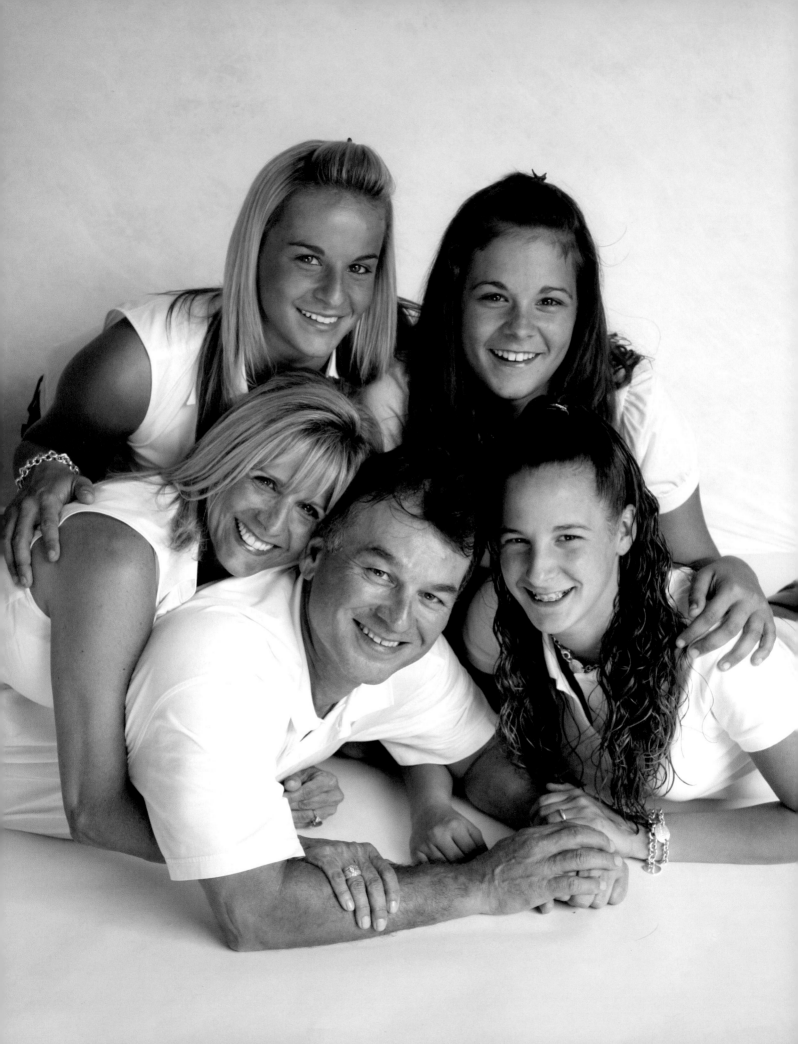

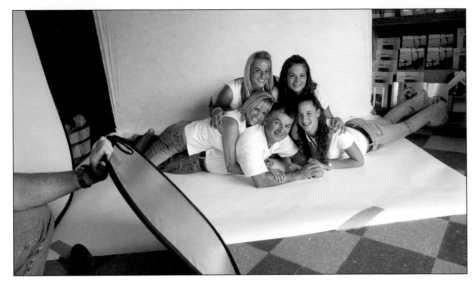

Light from a doorway is just like light from a window. Here, illumination from the very large opening served as the main light for a family portrait. Reflectors were used to bounce light back onto the shadow sides of the faces.

from one facial view to another during the session. Here's the secret: When photographing with a light source that you cannot move, you have to position your subject's face to attain the proper lighting first, then adjust your camera position to get the desired view of the face. In other words, when you can't move the light, move the camera.

Position the Subject. Many photographers have trouble finding the right pattern on their subjects' faces. Often, this is because they are not standing in the right place. To really see what you're doing and to "set" the light pattern, you need to be standing against the wall—right next to the window. Your subjects should be standing a few feet away from the window and around the middle or slightly closer to the far end of the opening. Then, turn the face toward the window—but not directly into the window. When you do that you get flat lighting and lose all dimension to the face. Once you see the desired pattern, keep the subject's face in place and pose the body to support the face.

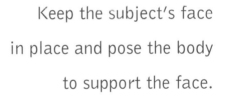

Keep the subject's face in place and pose the body to support the face.

Position the Camera. Once the proper pose is achieved—that's it; you cannot turn the subject to achieve full-face, two-thirds, and profile views. Instead, you will move *the camera* from one position to another. For a full-face picture by a window, the camera will need to be located right against the wall by the window. That's the only place that you can position yourself and still get a proper light pattern. For a two-thirds view, move away from the wall toward the center of the room. For a profile, move still further into the room. Because the subject and the window remain stationary, the lighting on the subject's face will be consistent.

USING A REFLECTOR WITH WINDOW LIGHT

When placing a reflector to enhance the window light you have two choices— just as you do when using a reflector in the studio (see chapter 7). If the light pattern is already there and all you want to do is to open up the shadows, then the reflector goes on the shadowed side of the face. If, however, there is light only on one side of the face, there is no light in the eyes, and there is

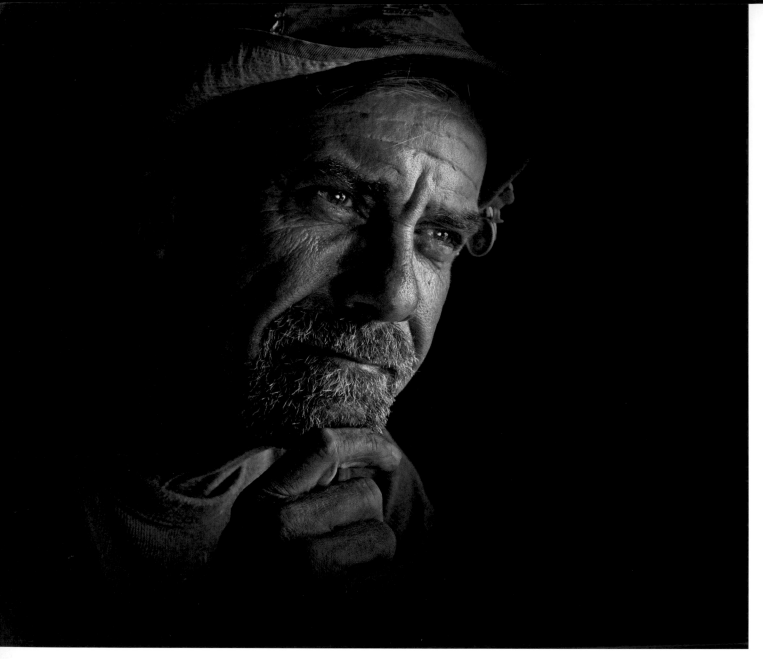

no appropriate lighting pattern, then the reflector should be placed on the highlight side of the face; it is what will create the lighting pattern for you.

Reflector for Fill Light. The most common use for a reflector is to open up the shadows in a portrait, allowing you to render detail throughout the image. When used for this purpose, the reflector should remain forward of the face, not beside the it. When it is in front of the face, it can pick up the light from the window and push it around to open up the shadows. When it is beside the face, on the other hand, it tends to act like a second main light source, bringing in noticeable light from the side opposite the main light.

Reflector for Main Light. Another use for a reflector is when the window lights only half of the face. In this case, what you need is an appropriate main light. To accomplish this, the reflector should be placed on the highlight side of the face and, initially, turned toward the window. Then, slowly turn the reflector until it bounces the light onto the shadow side of the face and creates the desired lighting pattern.

In some cases, a reflector can be be paired with window light to be used as the main light.

9. OUTDOOR PORTRAITS

M ost photographers today tell me that they like to work outdoors. They say that they like the natural settings and being less restricted than working indoors. That all sounds fine—but it's a heck of a lot more difficult to find or create good lighting outdoors than it is indoors. Outdoors, the conditions change from moment to moment; indoors, you can concentrate much more on your subjects, because so many of the variables are gone.

LOCATION SELECTION

Outdoor photography is challenging, but the results can be dramatic.

So how do you begin to choose an outdoor location for portraiture? There are a few approaches. Start by asking yourself what's important: the scene or

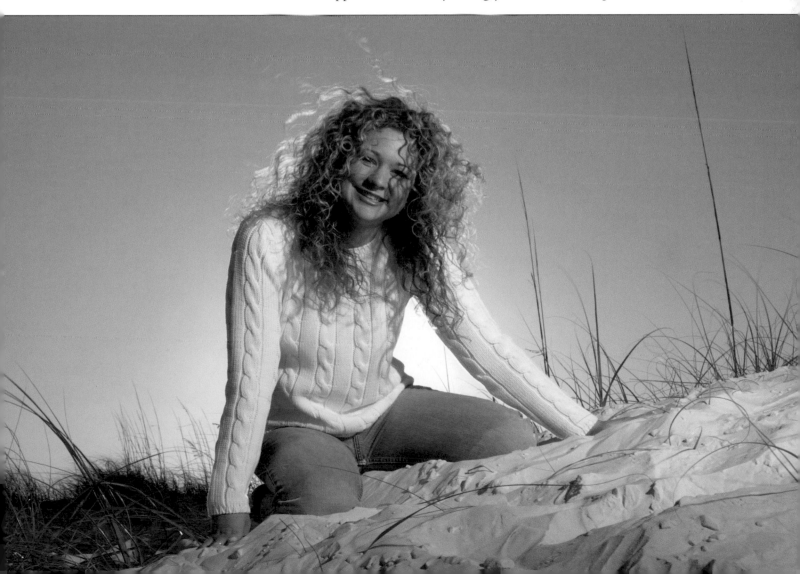

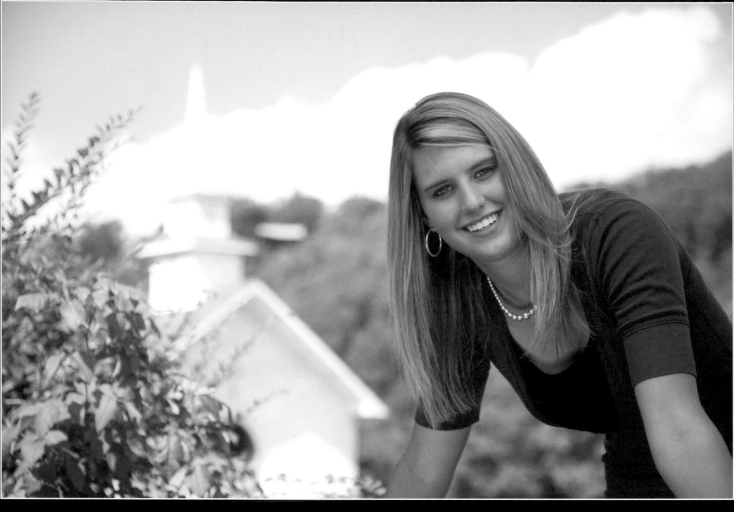

Sometimes, the location is important. In that case, you can often modify the lighting on the subject (here, by using a scrim overhead and a reflector for fill) to create a flattering portrait.

the lighting? Both approaches are viable; for best results, they should be used in conjunction with one another.

Find the Right Scene. If it's the scene itself that is important, then you need to locate a scene with lots of depth. The background should also have light falling on it, so it won't go dark if you have to add a flash on your subjects. Additionally, you should look for a background that is not distracting. For instance, you will want to avoid backgrounds where bright light comes down through trees; this will create a dappled effect that distracts viewers from the portrait subject.

Find the Right Lighting. Another approach to creating portraits outdoors is to find a situation where you have ideal lighting—a place where you *know* that you can create nice portraits. Then, look to see how you can control the background effectively. If necessary, you can put up your own background when you feel that you've found great light for your subject.

Sometimes the availability of good lighting is a deciding factor. To create a professional-quality portrait, however, you still need to determine how best to use the background.

LIGHTING

Fortunately, good outdoor lighting situations exist all around us—we simply need to train our eyes to see them. When good light isn't readily obvious, we

also have to know where to look for it. Most of all, when there's no good existing light at a location, we need to know how to create it.

Shade. Some of the best locations for outdoor portraiture are in the shade—particularly areas where there is little or no light coming from above. Ideally, you'll find a location where light is coming from one basic direction, rather than from all around your subjects. (*Note:* If there's unwanted light coming from another direction, you can simply cut it off with a black gobo. I use the reflector I had Westcott design for me: the Monte Illuminator. It is a silver/black reflector, and when I want to cut off light from any direction, I simply use the black side to block the light.)

When you see light next to shadow, you can be certain that there's an opportunity there for good portrait lighting. The easiest place to find this type of lighting is under a covered porch. Open garage doors also work well. I like to stay close to the edge of the opening, but under cover just enough to have a strong main light coming in from the side.

Another good place to look for directional lighting (that is still blocked from overhead) is at the outside edge of a foliage canopy. (*Note:* Contrary to

The first thing that I look for outdoors is a place where light will not be coming down from above. Finding good directional lighting is the goal.

This is a great location for outdoor portrait photography, but most people would pass it by without ever thinking of it. The background is also far from the subject, so the foliage is thrown out of focus, keeping your eyes on the subjects.

At the edge of the shade created by this tree, all that was needed to produce great lighting was a little reflected fill.

popular opinion, unless the bottom branches of a tree are much higher than the subject, the best light is not found at the tree's trunk—it's out just under the ends of the branches.)

I always suggest that photographers position themselves on the shadowed side of their subjects and photograph out into the lighter area. That way they get nice separation light on the back edges of their subjects and they won't have to worry about their backgrounds going too dark and virtually disappearing. At the same time, they will be creating great depth—something that we should all strive to accomplish in our photographs. Again, shoot from the shadow into the light.

Direct Sunlight. Good lighting can even be found outside in direct sunlight. If you have the option to conduct your session just before sunset, you can use the direct sunlight as your main light source. Sometimes, however, you may need to create portraits in a location where there is direct sunlight that is too bright or harsh to illuminate the subject effectively. In these situations, I use a scrim to soften the light. I always carry a Westcott Illuminator, a 48x72-inch collapsible diffuser, with me whenever I am shooting outdoors. Scrims soften sunlight and reduce its intensity, while retaining its color and quality. They also take away the harsh shadows normally associated with direct sunlight. In short, they produce soft, beautiful portrait lighting.

Good effects can also be achieved by backlighting or sidelighting on the subject, then adding some sort of fill light. Reflected fill is not really an option in these brightly lit circumstances; it will cause your subjects to squint. Therefore, flash is the best option.

If you want to retain good detail in the sunlit background, set the exposure for the background. Then, use the flash to balance the light on the subject with the exposure of the background. I try to use the flash on

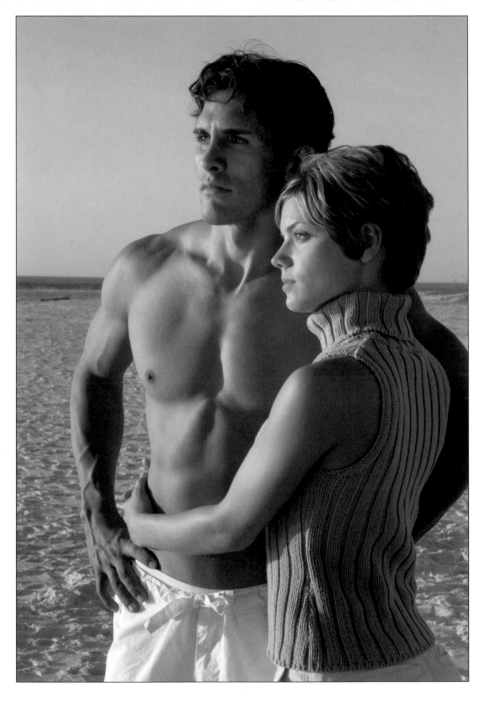

If you have the option to conduct your session just before sunset, you can use the direct sunlight as your main light source.

When positioning the scrim, you have several options. You can use it as the main light and place it where the main light would go. Think of it as a large softbox illuminated by the sun. To open up the shadows, use either a reflector or an off-camera fill flash, as in this example.

Using a scrim overhead diffuses the direct sunlight. With the addition of a reflector to fill the shadows, you can produce very nice portrait lighting in conditions where the unmodified light would be unusable.

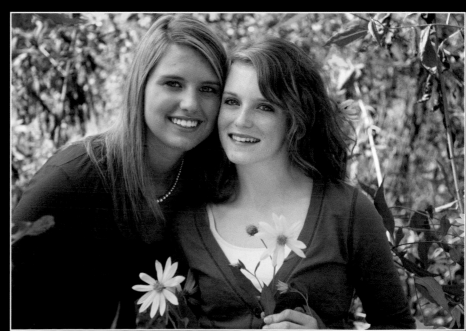

If an outdoor background is too distracting, you can simply replace it. In this image, a low-key portrait was created using a black gobo behind the subject.

the same side from which the direct sunlight is coming, but that's not always a necessity. (*Note:* The best way to measure flash in direct sunshine is to set the shutter speed on your exposure meter to a speed that is so short that it will cut out most of the ambient light. That way, your meter will be measuring just the burst of flash. Without using an exposure meter, you can always look at the image on the back of your digital camera and then go to the histogram to see if any parts of your picture are over- or underexposed.)

The other option in this situation is to expose for the shaded face, ignoring the bright sunshine in the background. Doing this, you can retain good detail in the face, but the background will be overexposed. If that is your intention—go for it. It's something I do quite often.

BARE BULB

If you take the reflector off your flash and use just the flash tube with nothing surrounding it, then you've got a bare bulb. I use this type of lighting when I want just a kiss of light to help shape my subjects in subdued light or when I want to put a little direct light into my subjects' eyes.

Without a reflector around the flash tube, the light no longer comes out of the tip of the flash tube. Instead, it comes out from the entire circumference of the tube. So, when directing a bare bulb at a subject, you don't point the tube toward the area you want to light. You let the side of the tube face your subjects.

A good starting point for balancing a bare bulb with ambient light in the shade is to expose for the natural light and bring in a bare bulb that is set approximately two stops less than the ambient light. (*Note:* To set the flash output, I use Quantum's QTTL Flash Adapter [model D-13W] on my camera. With it, you can dial in how much flash you want to use in relation to the ambient light [+3 stops to –2 stops]. This means you don't have to use an exposure meter at all to get the correct ratio of flash to ambient light.)

I use this type of lighting when I want just a kiss of light to shape my subjects.

10. CAMERA AND LENS

The *only* thing that counts is what the camera sees, and the only way to be certain of that is to look through the viewfinder—up to and through the moment of exposure. That means not even taking your eye away from the viewfinder to make eye-to-eye contact with your subject. Only when you're looking through the viewfinder can you be certain of what you'll be getting.

Ideally, you want the camera to see an undistorted, flattering view of the face and body. I achieve this simply by always looking through my lens when

The camera should be positioned so that you see the desired view of the subject's face. Here, it's a two-thirds view.

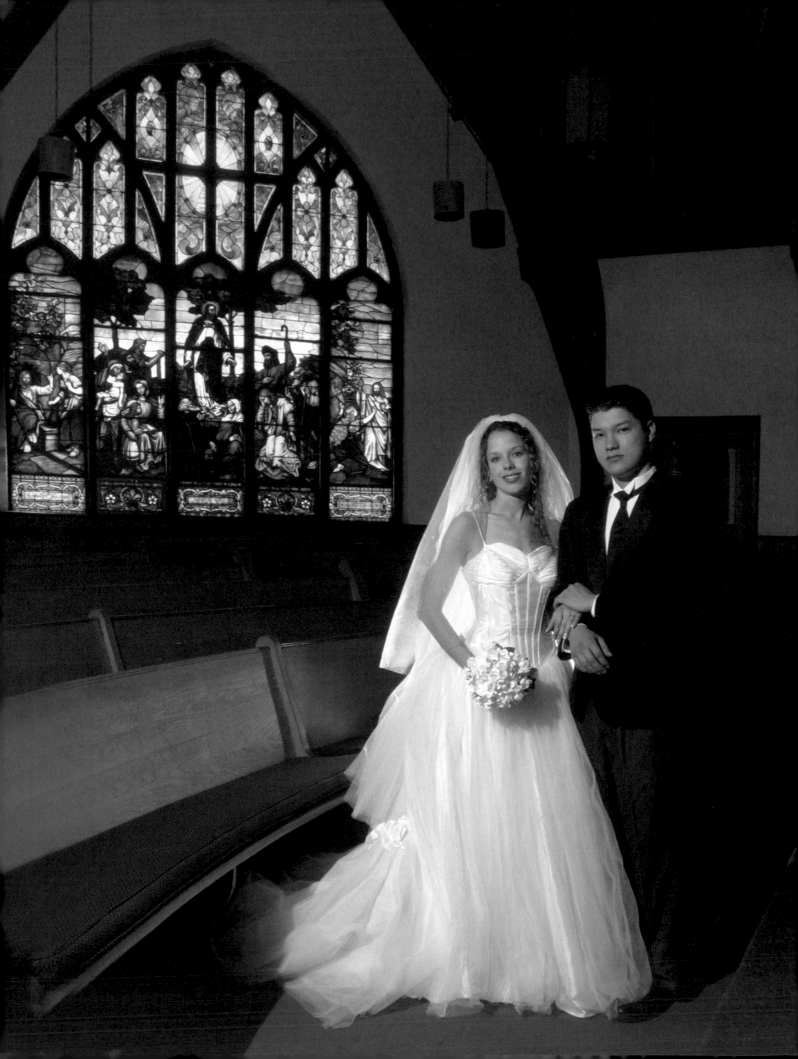

For full-length portraits, the camera should be at a height that keeps the camera back parallel with the subject plane. This may not be your normal standing height.

making the final adjustments to my subjects. I place the height of the camera where it needs to be for the amount of body that is showing, then adjust the subject's face up or down and/or side to side to look "normal." I don't want it to appear that you're seeing too much of the top of the head or to look like you're lying on the ground gazing up at the subject.

While looking through the camera, you might also see that lights and stands that are getting into your photographs. You really need an assistant to move distractions like this. You can't do everything yourself and still concentrate on your subject.

CAMERA ANGLE

Deciding where to place the camera is very simple: you should position the camera where it sees a specific angle of a face. Thus, the correct camera position is where you see either a full face, a two-thirds view of the face, or a profile. If it's not exact, it doesn't mean that the picture is no good at all—but chances are that if it were a more precise view of the face, it could be a *better* image. The determining factor is expression; if the expression works, I'd say that it's much more important than seeing an exact full face, two-thirds view, or profile.

CAMERA HEIGHT

The correct camera height is determined by placing the lens at that height where it will not distort the subject. It is very common to see mistakes made in this placement. I have found that many photographers shoot from whatever height they stand, never thinking about what camera height would be the most appropriate.

Full-Length Portraits. A good rule of thumb for full-length portraits is that you should keep the lens at a height where the plane of the camera's back is parallel to the subject. In practice, this means that the camera height should be midway between the top and bottom of the person—at *their* waist level, not yours.

If the camera is tilted upward or downward, you will be distorting the person. A camera height that is too low will make the person's legs look too large, while their torso will look too small. A photograph made from too high a viewpoint would make the person look top-heavy with short, stubby legs. (*Note:* This distortion can also be used intentionally. For example, by lowering the lens you can give your subject very long legs or accentuate a very large, full gown.)

Three-Quarter-Length Portraits. When photographing a three-quarter-length figure, either standing of seated, the camera's height should be midway between the cut-off point at the bottom of the figure and the top of the subject's head. The proper height of the lens, therefore, would be about the middle of the subject's chest level.

Head-and-Shoulders Portraits. You might think that the proper camera height for a head-and-shoulders portrait would be at the subject's eye level, but that's not usually the case. Instead, your camera should be slightly above the subject's face. If your subject is standing, this may mean you need to shoot while standing on a block or step ladder. Most convenient, of course, is to have the subject seated when doing a head-and-shoulders portrait.

Shooting from this camera height focuses attention on the face and minimizes the body. When you're composing the picture, be sure to adjust the subject's face up or down so that it appears normal when seen

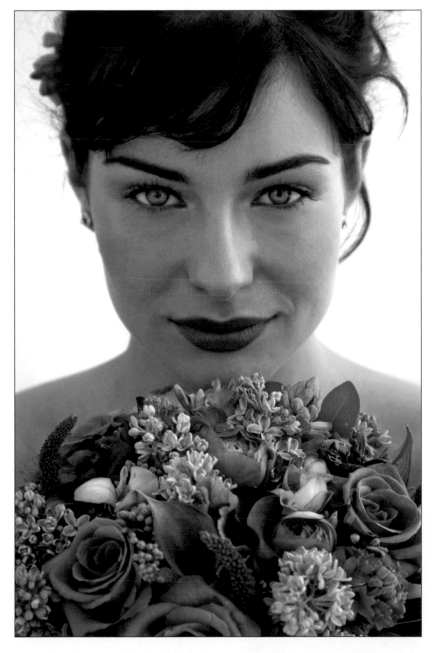

FACING PAGE—For three-quarter-length portraits, the camera should be at about the middle of the subject's chest level.

BELOW—For a head-and-shoulders portrait your camera should be slightly above the subject's face.

through the lens. You should *only* adjust the face when looking through the viewfinder; otherwise, you will not know what the camera sees and whether or not the face is being distorted.

Many photographers tend to bend over at the waist to photograph people. This can easily mean that the camera is too low, even when the subject is seated. Remember, you want the camera to be *above* the subject's face when doing a close-up. Do not bend over!

Profiles. Profiles look best when the camera is lowered to show a space between the subject's chin and shoulder. Then, you need to adjust the side of the face so that you're not seeing too much of the top of the head or too

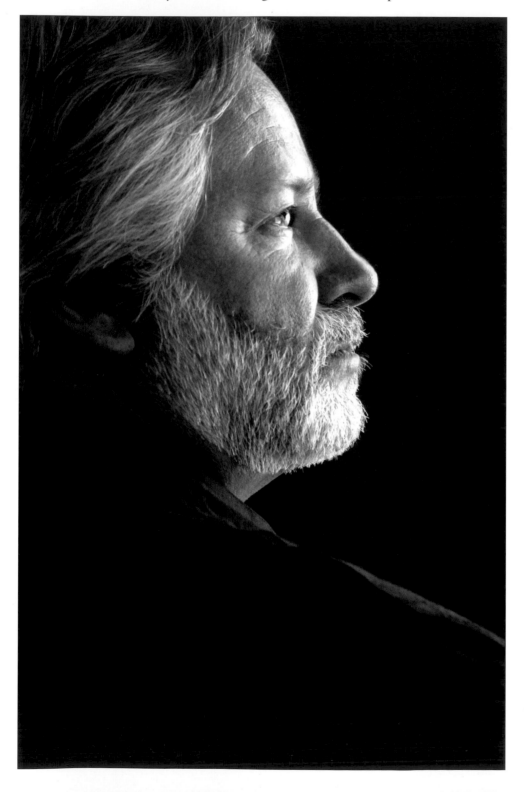

Profiles look best when the camera is lowered to show a space between the subject's chin and shoulder.

Tilting the camera can help accentuate the angle of the shoulders.

much of the chin. To solve this problem, your directions to the subject should be, "Tip the top of your head slightly toward the background/camera."

Controlling the Background. The height of your lens may vary from what's described here if you want to change the background behind the subject. If you're raising or lowering the camera for a specific reason like this, be sure to look through your viewfinder and adjust your subject's face to suit the altered height of the lens.

TILTING THE CAMERA

Often, I tilt the camera to dramatize the angle of the shoulders. When I do this, I usually *tip the top of the camera toward the higher shoulder.* This works

best, of course, when there are no straight lines in the picture to show that the camera has been tilted.

Be aware, however, that when you tip the camera, you sometimes lose the base of your composition. The leading edge of the arm that may, before the tilt, have come to the edge of the picture may now be down far from the corner of your viewfinder. When you see this happening, simply extend the arm out further until you've created a good base for the composition.

HAND-HOLD OR USE A TRIPOD?

I can't be without a tripod. Having my camera on a tripod at all times frees me to leave the camera for a moment to make adjustments to either the lights or the subjects and know that the camera will remain in position until I return to it. Of course, it usually means a sharper image, too. A tripod functions perfectly for me—except when photographing children who fly so quickly that I have to be able to move to any position and height instantaneously.

A tripod also lets you stay glued to the camera, allowing you to make refinements to a pose while looking through the viewfinder. Once you've positioned a person for a portrait, it's not necessary to continually return to your subject to make changes. Any needed refinements can be made from the camera position by telling the person exactly what you want them to do.

One of my recent finds was an extremely strong tripod: Bogen's Manfrotto Classic/Deluxe/Wilderness Tripod. No one is *ever* going to knock your cam-

Whether in the studio or on location, shooting from a tripod frees you up to leave the camera for a moment and make any needed adjustments.

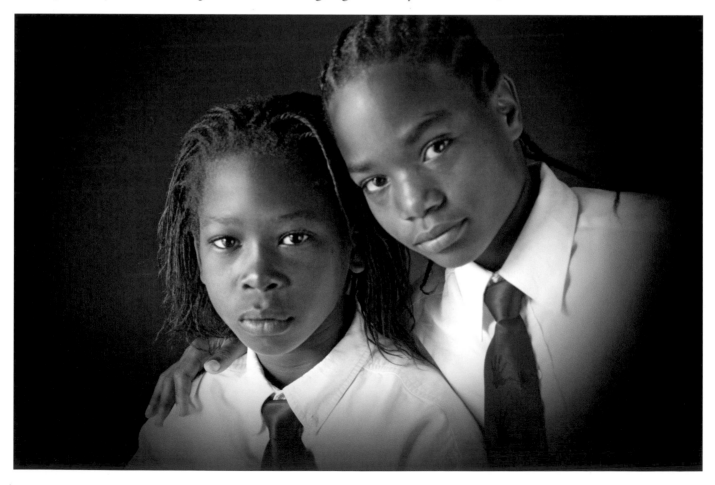

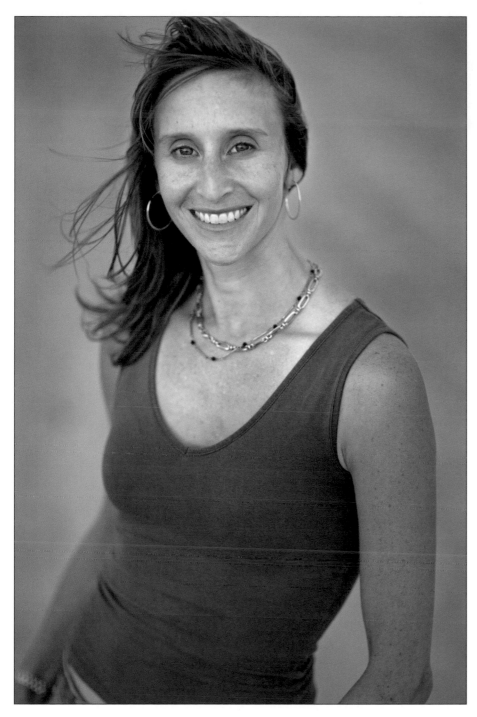

In this image, the background was blurred out by shooting at f/1.2 using a Canon EF 85mm f/1.2 USM lens.

era over when it's anchored to this—and the Manfrotto Pistol-Grip Ball Head 322RC2 is the perfect match. Another tripod I like, which is lighter in weight but incredibly flexible, is Bogen's 458B Manfrotto Neotec Pro Photo Tripod. It's a little more expensive, but definitely worth looking into.

If you are used to hand-holding, it may initially be difficult to learn to work with your camera on a tripod—but, when you start selling large prints, you'll be more than thrilled that you did. Keeping the camera on a steady tripod is definitely the way to go.

LENS SELECTION

Is there an ideal lens for portraiture? The lens you select for portraiture depends on the camera you're using. If there is a crop factor in your camera (*i.e.,* you're not getting the full view that the lens is capable of recording), you'll want a wider-angle lens. If the camera has a full-frame sensor (such as the Canon 5D) you probably won't need the wider field of vision.

Personal Favorites. I like to have the flexibility of a zoom lens, so with my 5D I use a Canon EF 24–105mm f/4L IS USM lens. With my Canon 30D, I use the Canon EF 24–70mm f/2.8L USM lens. Another great lens for portraiture is Canon's EF 85mm f/1.2L USM. With the lens wide open you can blur out just about any background and concentrate just on the face of your subject.

Telephoto. When I want to come in close on my subject and, at the same time, limit the amount of background that I show behind them, I use my long lenses. I enjoy tight cropping, eliminating distracting elements from my compositions. I also like the feeling of compression I get with the long lenses. This brings the background up much closer to the subject than I get with a normal focal length. I can also photograph with the lens wide open and get a very shallow depth of field. The out-of-focus background is sometimes ideal

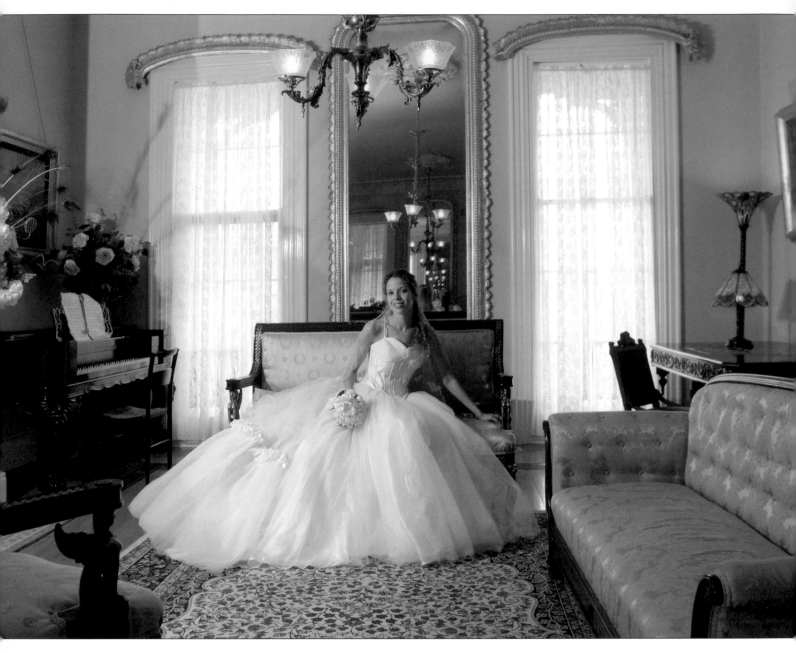

for outdoor portraiture. My favorite telephoto lens is a Canon EF 70–200mm f/2.8 IS.

Wide Angle. Then, there's the other extreme: wide-angle lenses. Wide-angle lenses allow you the luxury of having your main subjects large when they're close to the lens, while simultaneously including a lot of background. This is extremely useful in a situation where you want to include as much of the area behind the subjects as possible. In an instance such as this, I like to use the Canon RG 16–35mm f/2.8L USM lens.

The "normal" focal length lenses are useful, but I've found that I use wide-angle lenses more than the normal ones. In particular, I like them when I'm doing family portraiture in the home. With my subjects away from the background (*i.e.,* close to the camera) I'm still able to show the interior of the home behind them.

Wide-angle lenses allow you to show a lot of your subject's environment.

COMPOSING THE IMAGE IN CAMERA

Personally, I don't always think that the picture *must* conform to a predetermined shape. I compose to suit the subject. Of course, I usually try to compose the complete frame in my viewfinder, but sometimes I think, when I'm taking the picture, that a particular image may eventually end up in a different shape—be it square or rectangular. As long as I think about this in advance, I know better how to compose the picture in my camera. The following are a few guidelines for in-camera framing of your images.

Include Some Body. When cropping any portrait, I always try to make certain that there's a broad base to the bottom of the composition. A mistake

When cropping, make certain you retain a broad base at the bottom of the composition. This is required to visually support the face.

This is one of the most

often missed priorities

when composing a portrait.

that many photographers make is that they don't include enough of the subject's body to support the face. Make certain that you don't have heads resting at or near the bottom of a portrait.

Use the Rule of Thirds. In general, crop so that the strength (the focal point of the picture) is approximately a third of the way from the top or bottom of the portrait. Thus, for a head-and-shoulders portrait the eyes should be one-third of the way down from the top of the frame. If you see that the eyes are in the middle of your viewfinder, you've usually got too much space above the top of the head. Without a doubt, this is one of the most often

missed priorities when composing a portrait in the camera. Beginning portrait photographers often center the head vertically in the viewfinder instead of keeping it above the center line.

In a close-up portrait the strongest position for the eyes is about one-third of the way from the top of the photograph. If the subject's eyes are in the middle of the picture, it often appears as if he is falling out the bottom of the frame. For extreme close-ups, cropping this way will sometimes mean cropping off the top of a head, some of the hair, or a bit of a bride's headpiece. When you do this, be sure to tell the subject what you're doing and why—otherwise, you will undoubtedly get a complaint later. Also, it's a good idea to have samples of this tight cropping readily available to show people that it is acceptable to compose a portrait this way.

Subject Placement. When a subject is turned with their full face toward the camera, you should keep the face centered horizontally within the frame. When the face is turned toward one side or another, as in a two-thirds view or a profile, you should leave more space on the side of the frame toward

For close-ups, cropping so that the eyes appear in the proper position will sometimes mean eliminating the top of the subject's head.

which the face is turned. This allows room for the subject to look into the portrait, rather than out of the frame.

In a profile, the front edge of the face is generally just past the middle of the frame. Otherwise, if the front edge of the face is near the edge of the picture, the center of the portrait becomes the subject's ear. I've noticed that, since I went completely digital and the rectangular format is what I've adapted to, I'm making most of my profiles in the horizontal position. That gives me plenty of room to place the edge of the face just a little past center and still show the back of the head.

A subject in the basic pose is usually composed so that the same amount of body appears on both sides of the chin. A heavy person can be turned slightly more away from the camera and cropped closely so that less of the body is visible. Be certain to show some of the shoulder on the far side of the subject, though; if the subject's body is turned at too great an angle to the camera, it may appear that his rear arm has been amputated.

There should be a little space in front of the subject—room for them to look across the frame.

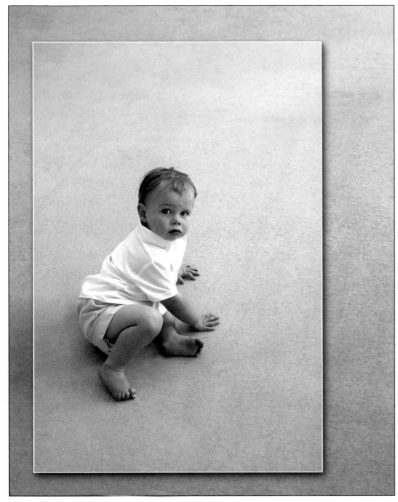

FACING PAGE—Little children need space around them to show that they are small.

ABOVE—Using a high camera angle emphasizes a child's small size—and shows the child from the angle their parents are used to seeing them.

You should also avoid composing an image so the edge of the frame cuts into the middle of the hands, wrists, legs, etc. I try to contain all the body parts within the composition, or I leave them out completely.

SIZE OF THE SUBJECT IN THE FRAME

For the most part, my style of portraiture involves coming in close to my subjects. I try to create the feeling that you're looking in through the subject's eyes to the soul of their being. What's unnecessary in the picture is left out—right from the start.

Children. When I'm photographing little children they need space around them to show that they are small beings. For example, in a full-length picture of a child, I leave more space above the child's head than I would in the same portrait of an adult.

To decide how much space to leave, I use the outside dimensions of the photograph as a frame of reference. For a full-length portrait, I think of the child as standing in the frame of a doorway. Even if the child is seated in the portrait, I still consider how tall that person would be if he were to stand up. I then back off until the child has a "normal" size relationship with the imaginary doorway. There will be lots of space above the child in the picture. Again, you must discuss what you're doing with the parents while you're creating the composition in your viewfinder. Otherwise, you will eventually get the question, "Why didn't you come in closer when you took the picture?"

Head Size. In general, the accepted head size for a portrait is slightly smaller than life-size. Larger-than-life heads in pictures are not attractive. So, if you're planning to make a large portrait, be sure to either include a good amount of the body in the frame or a lot of space around the figure when you're creating the original image. If you're planning to make a large print of a close-up or three-quarter-length portrait, you may even need to add a vignette. This can be done either in the camera or afterwards on your computer.

12. EXPOSURE

WHAT IS A PROPERLY EXPOSED PHOTOGRAPH?

A properly exposed picture is one that has a full range of tones—highlights, midtones, and shadows. There should also be detail throughout, from the brightest specular highlights to the deepest shadows. A properly exposed digital file is one in which these tones fit within the range that can be printed on photographic paper and still show the same detail.

FILM OR DIGITAL?

By this time, digital is a foregone conclusion. After all, there is nothing that film can do for me that I can't do better and more easily digitally. Is there a

A properly exposed picture is one that has a full range of tones with detail throughout.

With digital, you must be careful not to over-expose the highlights.

If there is no detail in the highlights, there is no easy way to bring it back.

difference? Sure, there is. Digital tells me what I'm doing and how well I'm doing it. Can you tell the difference between a print made from film and a print made from digital? I can't.

The main difference between exposing for film and digital is that when using negative film you exposed for the shadows. When exposing for digital, on the other hand, you should expose for the highlights. If there is no detail in the highlights, there is no easy way to bring it back.

Fortunately, determining whether or not you have the correct exposure has never been easier: just check the back of your camera. Start by looking at the image itself. If there's a big problem, you'll see it right away. If the shot

passes visual inspection, check the histogram just to be sure. Make certain that the darkest blacks and the whitest whites are all contained within the histogram. In particular, if the highlight side goes beyond the edge of the histogram, you'll know that you are losing detail in some of your lighter tones. If your camera has a flashing-highlights preview feature (a viewing mode in which pure-white areas flash on the screen) it's easy to see where the overexposed areas are and make a decision as to whether or not they are important. If the overexposed elements are part of the background, you may not care at all. If they are within the main part of the photograph, you'll definitely want to make some exposure adjustments.

EXPOSURE MODES

Aperture Priority. When I'm working with continuous light sources, I use the aperture-priority mode on my camera. In this mode, you select the lens opening you wish to use, then the camera selects the correct shutter speed to go along with it for each image that you create.

With continuous light sources, I shoot in the aperture priority mode.

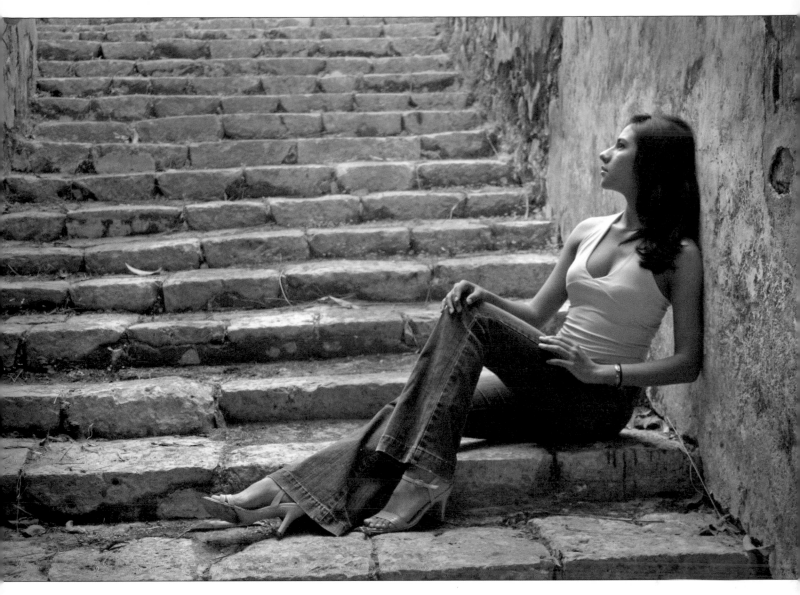

In the aperture-priority mode, you select the aperture you want to use and the camera sets the shutter speed.

Sometimes, of course, you have to override what the camera selects. For instance, when you're photographing a person in dark clothes against a dark background, the camera will see all that darkness and overcompensate, thinking that you need to let a lot more light in. As a result, the faces will be overexposed. When that happens, it's easy to reduce the exposure by a stop or two using your camera's exposure compensation settings. Conversely, if you're photographing light clothing against a light background, the camera may set a shutter speed that would make the face too dark. Again, you can just override that by increasing the exposure compensation.

I have found it much easier to shoot in the aperture-priority mode than to continually take exposure meter readings and use the manual settings for each exposure. Therefore, aperture priority works for me almost all the time—except when I'm shooting flash.

Manual Mode. You can't work in the aperture-priority mode when exposing with flash; the camera would pick up the ambient light before the flash went off. Instead, you must work in the manual mode.

To do this using an exposure meter, get an exposure for the main light by turning off all other lights and pointing your meter at the light. Once you know the exposure for the main light, set up a fill light at two stops less intensity and you have it made.

Since going digital, however, I have stopped using an exposure meter. I set the flash at the distance I want, the dial in f/16 on my camera while firing the main light. Then, I make adjustments to the aperture until I'm perfectly satisfied with the results. This may not be the optimum way to get the right exposure, but it's how I do it. Of course, if you move the flash, it's definitely going to change your exposure.

When shooting with flash, you need to switch over to the manual mode.

Under constantly changing lighting conditions, a preset white-balance setting is sometimes necessary to expedite shooting.

ADDITIONAL EXPOSURE DECISIONS

ISO. Before my shoot, I select the ISO setting that will work best with the given light situation. Outside in bright sunshine I usually use ISO 100 to 200. In lower light, I bump up the ISO to anywhere between 400 and 1000. It's almost like we used to select the right film for each application—only with a digital camera, you can switch the ISO with each picture, if you so choose.

White Balance. When we used film to record our subjects, we selected the correct film for the light source we were using. In digital, however, we tell the camera what light source we're using by setting the white balance.

While the automatic white balance (AWB) setting may be practical for amateur photography, it is definitely a no-no when doing quality imaging. For professional results, today's digital cameras have various built-in selections that provide much more consistent colors. My Canon cameras, for instance, have settings for sun, shade, clouds, fluorescent light, flash, and more. Choosing the appropriate setting from among these choices will give you a much better color balance than going the automatic route.

I used these settings for a long while—until I discovered how easy it was to create a custom white balance using an ExpoDisc from ExpoImaging in front of my lens. Now, I do a custom white balance for everything. The time

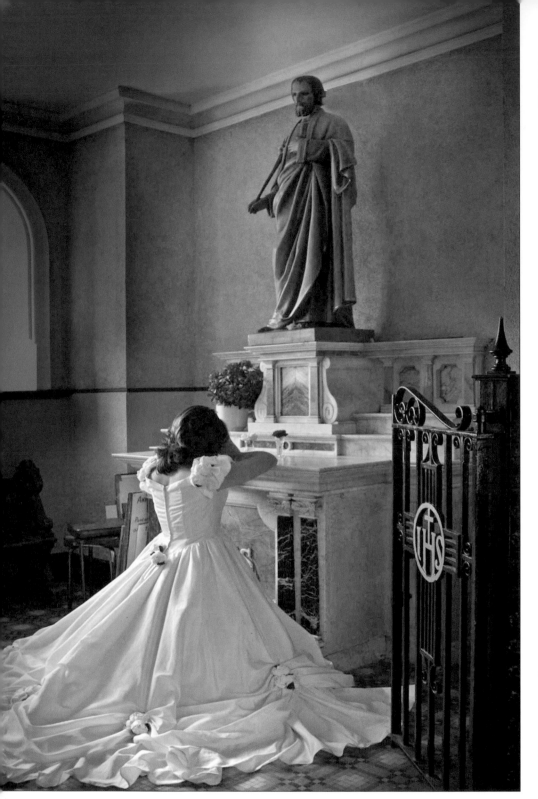

This gives me the option to modify my color balance and exposure . . .

spent doing this before exposure saves an incredible amount of post-production work. Time is money, after all!

Today, the only time I *don't* use a custom white balance setting is when I'm shooting outdoors under constantly changing light conditions. There, for expedience, I often use the presets mentioned above. (*Note:* In such situations, when I don't have complete control of everything, I also shoot RAW and JPEG files simultaneously. If necessary, this gives me the option to modify my color balance and exposure after taking the pictures.)

File Format. Under conditions when I have total control of exposure and white balance I'm happy shooting large JPEGs. Whenever there's a doubt in my mind (or when conditions are constantly changing, as noted above) I shoot JPEG and RAW files simultaneously. Even though I may not use most of the RAW files, they give me peace of mind. I know that I don't have to take my attention away from my subjects and get too technical with my shooting when I'm shooting RAW. It takes a little more storage space, but that small investment is well worth the price. It's like an insurance policy that I know I can rely on when necessary.

When conditions are constantly changing, such as at a wedding, I shoot JPEG and RAW files simultaneously.

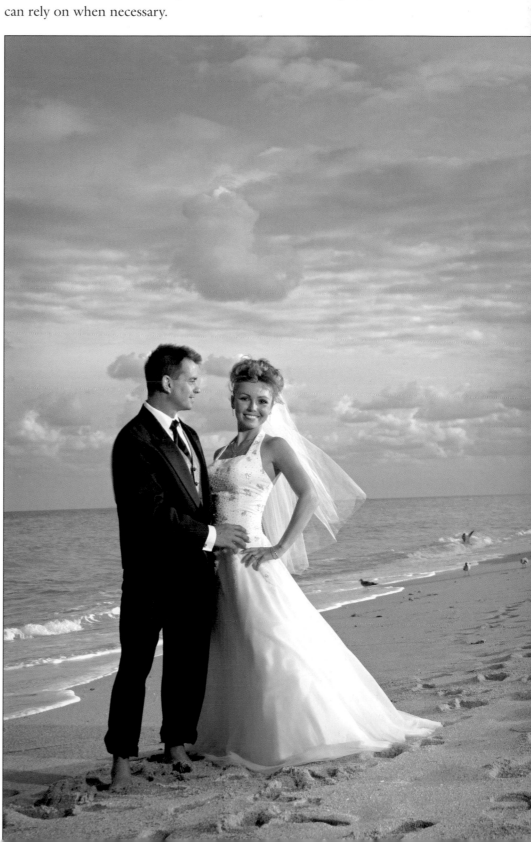

With RAW files, even relatively large exposure problems can be corrected after the shoot just as effectively as if you had made the adjustment in-camera. That can cover mistakes of judgment when the picture was taken, or it could be a saving grace when you need more exposure than the camera will allow. This came to me when I was recently photographing a wedding in a church that was so dark that, even at ISO 1600, the correct exposure was too long to hand-hold the camera. I deliberately underexposed the pictures by *three* f/stops, so that I could shoot at a shorter shutter speed and get no camera movement. When I brought those exposures up into my computer I was able to increase the exposure to what would have been considered a normal exposure under those circumstances—with absolutely no apparent effect to my photographs.

At that same wedding, I was moving very quickly from one location to another. At one point, I was exposing in direct sunlight and had the camera set for that. A moment later I was taking portraits in open shade and forgot to change the white balance. Having duplicated all my exposures by shooting in RAW and JPEG simultaneously, I was able to adjust for the open shade with a single click on my computer. Life in the digital world is good!

In many situations, shooting RAW files gives you the flexibility to fully achieve your vision for an image.

SOFT FOCUS

My philosophy for portraiture is that I don't want to necessarily show people as they are. Instead, I'd rather show them as *I* would like them to appear or how I think that *they* would like to appear. I feel that if they didn't want to be seen at their best, they wouldn't take so much time grooming themselves before coming out into the public.

To this end, I feel that photographing with a soft-focus lens or filter is appropriate. I own a Canon EF 135mm 1:2.8 soft-focus lens. You can vary the degree of softness by the settings on the barrel of the lens, as well as the f-stop you're using. It's not expensive and does a wonderful job. When working

By creating your soft-focus effects after the shoot, you can apply diffusion very precisely and maintain the desired sharpness in critical areas.

digitally, however, I prefer to shoot sharp and then add the soft focus in Photoshop. I have much more control that way—*much* more!

It should be noted, however, that soft focus does not eliminate the need for retouching. Soft focus and retouching are two separate entities. Three-dimensional lighting creates lines in faces that aren't usually there when someone looks into a mirror with totally flat lighting. Therefore, we need to soften the "shock" of our subjects seeing themselves under portrait-lighting conditions. That's where Photoshop comes into play.

BLACK & WHITE

Although my new Canon cameras give me the option of shooting directly in black & white, sepia, etc., I still prefer to shoot in color. That way, I have the option to convert to black & white or any of the other tones that I may choose. I'm not always certain which pictures I want to have in black & white until I see them on my computer screen. Sometimes, color actually can get in the way of the enjoyment of a picture—especially in portraits. With digital, I'm able to view my pictures both in color and black & white to make the final decision as to which I prefer.

There are several ways of converting color to black & white. My favorite technique is to change the mode of the file to Lab Color. Once in Lab, go to the Channels palette and click on the Lightness channel. The picture will

FACING PAGE—Portraits designed to have a classic Hollywood feel are almost exclusively presented in black & white.

BELOW—Sometimes, color can get in the way of your enjoyment of an image. Using digital imaging software, it's easy to convert to black & white.

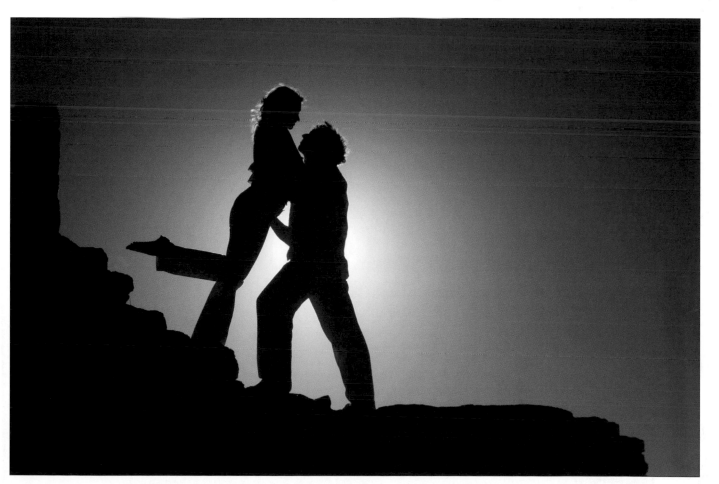

In portraiture, presenting your image in black & white is often the most effective way to eliminate distractions and get viewers to focus on the character reflected in the subject's face.

To refine my black & white portraits I often use the Burn and Dodge tools . . .

change to black & white with a full range of tones that seem, for me, to be better than all the other methods for conversion. Of course, to get rid of the color in the file you'll have to go back to Image > Mode > Grayscale. After that, I switch back to the RGB mode and continue working there, making my final adjustments to brightness and contrast using the Levels command.

To refine my black & white portraits even more and give them more character, I often use the Burn and Dodge tools to brighten some of the highlights in the face and darken some of the creases. I do the same with the eyes. For a final touch, I sometimes use the Sharpening tool (located under the Blur tool) to bring out more detail in the eyebrows, lashes, etc.

With these methods, the black & white conversions that I'm getting from my color digital files are far more beautiful than anything that I ever achieved when I was shooting with black & white film. Of course, a lot of that may be a result of the fact that I'm much more aware of lighting than I ever was back in the "old days."

INFRARED

Infrared portraits are magnificent. I have a Canon digital camera that was adapted to create *only* infrared pictures. (*Note:* To obtain one of these cam-

Infrared images have an ethereal quality that sets them apart from other portraits.

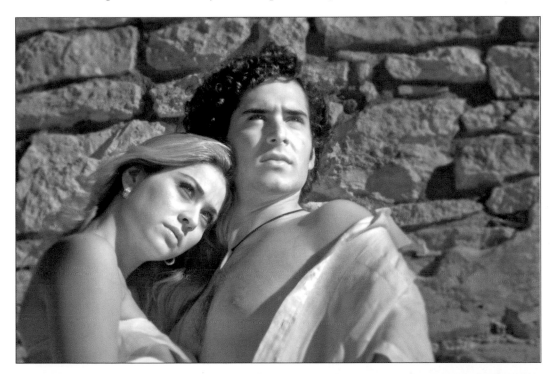

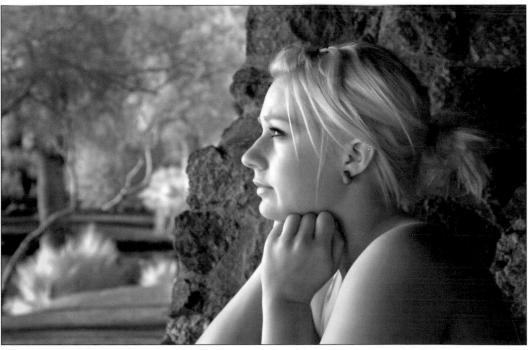

eras, visit www.irdigital.net.) Infrared works best in bright sunshine, rendering the tones in dramatic ways—green foliage turns white, blue skies turn very dark, and skin tones come out like porcelain. Full-length scenics in infrared are in a class by themselves. For a great addition to your repertoire, I recommend it highly.

The pale glow of foliage in infrared images is one of its defining characteristics.

CONCLUSION

A FINAL CHECKLIST

The most important thing that I can tell you is to plan the entire portrait in your head before you start posing your subject. See the completed portrait in your mind's eye. See the placement of your subject and the placement of your lights. Once that's done, it's a simple matter to complete the task.

If, on the other hand, you start posing your subject with no goal in mind (or if you start changing your mind), you'll end up constantly adjusting your subject, lights, and props. This wearies your subject and makes you look unprofessional.

Having a goal in mind is critical to the success of your shoot.

The following is the process I use to set my goals for the shoot.

1. To which side am I going to turn my subject's face (for a two-thirds view or profile)?
2. Will the subject be in a basic or feminine pose?

With those two questions answered, you should know pretty much exactly on which side to place the lights, as well as how you'll need to position the posing stool, the camera, and anything else you think you may need. You know in which direction to seat the subject. With these decisions made, by the time your subject is seated, everything should already be roughed into position.

Now, let's assume you are going to proceed to make a head-and-shoulders portrait of a seated man. Here is the process—picking up with your subject seated on the set.

3. Place a posing table in front of the subject. Remember that the table will always be there to support the arm of his lower shoulder.
4. Lean the subject's body forward at the waist and place his arm/elbow out away from his body, with the forearm and hand angled back toward the body.
5. Raise the subject up to his fullest height, while keeping him leaning forward (over his belt buckle).
6. With your camera on a tripod, position the lens to see the exact angle of the face you want to photograph.
7. Place the camera at a height that keeps the camera back parallel with the subject.
8. Position the main light carefully to get it into both eyes, lowering it if necessary. Study the pattern of light to make certain that you have the modified-loop pattern and that there is shadow along the side of the nose closest to the camera.

Place the camera at a height that keeps the camera back parallel with the subject (or subjects).

9. Feather the main light just enough to cast part of it past the subject and onto the reflector.
10. Make certain that the reflector is in front of the face and not along the side of the face.
11. Look for distracting details (in clothing, hair, etc.) and take care of them.
12. Check to see that the background and/or veil light are a little stronger on the main-light side of the face.
13. Tip the camera, if desired, to achieve final composition. I usually tip the camera toward the higher shoulder. Once in a while you can tip the camera toward the lower shoulder to change the composition entirely.
14. Check to see that you have a solid, broad base at the bottom of the frame to support the composition.
15. Check cropping to make certain that the eyes of your subject are about a third of the way from the top edge of the frame.
16. Check to make certain that there is extra space in front of the subject's face when photographing a two-thirds view or profile.

Make certain that there is extra space in front of the subject's face when photographing a profile.

17. Check again to make certain that you are seeing the specific angle of the face you want.
18. Make final adjustments while looking through the lens.

A LIST OF THINGS TO AVOID
Don't waste your time or your subjects' time.
Don't make final adjustments while standing close to your subject. The only place from which to finalize a picture is through your lens. If you're not looking through the lens, what *you* are seeing is not what the *camera* is seeing.

Don't ask your subjects to look at your hand.
As soon as you move your hand away they have nothing to focus on. Instead, you should have them look at a place on the wall and then have them move their eyes one inch at a time in any direction necessary to center their eyes.

The only place from which to finalize a picture is through your lens.

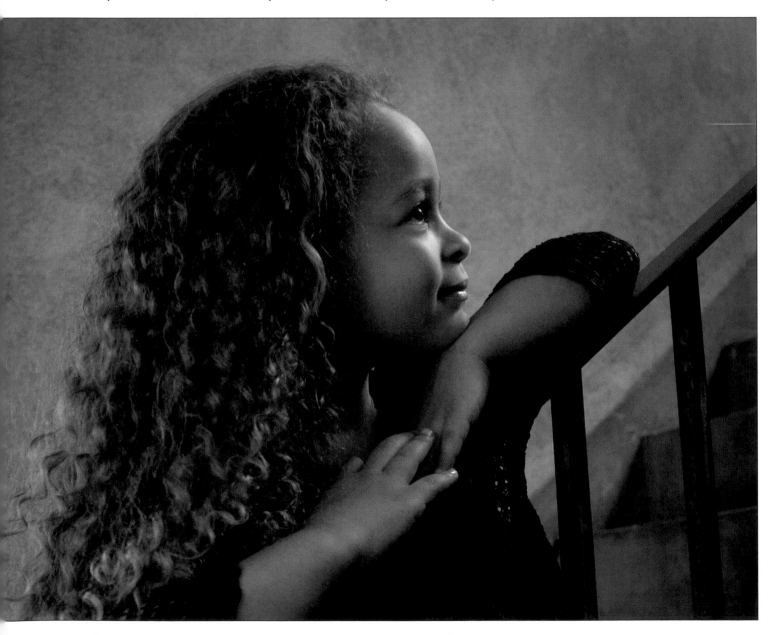

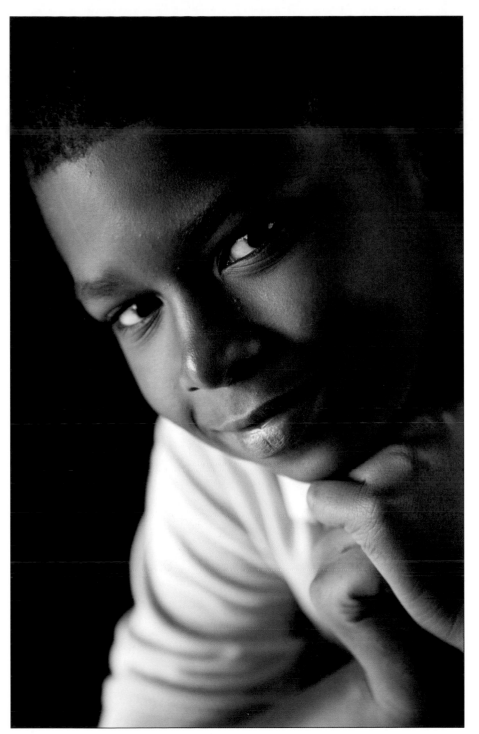

A great expression is one of the keys to a great portrait—but counting is not the way to get it.

Don't count, "One! Two! Three!"
Counting doesn't get the expression you're looking for. As a matter of fact, I think that counting is one of the most useless things that you can do. It's been my experience that it only makes people more self conscious and nervous that their picture is about to be taken.

Don't think that your subjects always know best.
You're the artist. You're the person who knows best. Be nice, but be firm—especially when it comes to appropriate dress for the portrait.

Don't forget to listen to your subjects' needs.
Your subjects usually—well, *sometimes*—know what they want. Listen and act accordingly. If you disagree with them, learn how to make your point without endangering their opinion of you.

IN CLOSING

We've now worked through the portrait process from start to finish. As I mentioned in the introduction, mastering these techniques will require practice—and lots of it. So, make it your goal not to settle for "good enough" and begin the process of reaching your maximum potential. Good luck!

INDEX

POSING FOR PORTRAIT PHOTOGRAPHY
A HEAD-TO-TOE GUIDE

Jeff Smith

Author Jeff Smith teaches surefire techniques for fine-tuning every aspect of the pose for the most flattering results. $34.95 list, 8.5x11, 128p, 150 color photos, index, order no. 1786.

GROUP PORTRAIT PHOTOGRAPHY HANDBOOK
2nd Ed.

Bill Hurter

Featuring over 100 images by top photographers, this book offers practical techniques for composing, lighting, and posing group portraits—whether in the studio or on location. $34.95 list, 8.5x11, 128p, 120 color photos, order no. 1740.

PROFESSIONAL MODEL PORTFOLIOS
A STEP-BY-STEP GUIDE FOR PHOTOGRAPHERS

Billy Pegram

Learn to create portfolios that will get your clients noticed—and hired! $34.95 list, 8.5x11, 128p, 100 color images, index, order no. 1789.

THE PORTRAIT PHOTOGRAPHER'S GUIDE TO POSING

Bill Hurter

Posing can make or break an image. Now you can get the posing tips and techniques that have propelled the finest portrait photographers in the industry to the top. $34.95 list, 8.5x11, 128p, 200 color photos, index, order no. 1779.

MASTER LIGHTING GUIDE
FOR PORTRAIT PHOTOGRAPHERS

Christopher Grey

Efficiently light executive and model portraits, high and low key images, and more. Master traditional lighting styles and use creative modifications that will maximize your results. $29.95 list, 8.5x11, 128p, 300 color photos, index, order no. 1778.

PROFESSIONAL PORTRAIT LIGHTING
TECHNIQUES AND IMAGES FROM MASTER PHOTOGRAPHERS

Michelle Perkins

Get a behind-the-scenes look at the lighting techniques employed by the world's top portrait photographers. $34.95 list, 8.5x11, 128p, 200 color photos, index, order no. 2000.

RANGEFINDER'S PROFESSIONAL PHOTOGRAPHY
edited by Bill Hurter

Editor Bill Hurter shares over one hundred "recipes" from *Rangefinder's* popular cookbook series, showing you how to shoot, pose, light, and edit fabulous images. $34.95 list, 8.5x11, 128p, 150 color photos, index, order no. 1828.

MASTER LIGHTING GUIDE
FOR COMMERCIAL PHOTOGRAPHERS

Robert Morrissey

Use the tools and techniques pros rely on to land corporate clients. Includes diagrams, images, and techniques for a failsafe approach for shots that sell. $34.95 list, 8.5x11, 128p, 110 color photos, 125 diagrams, index, order no. 1833.

SOFTBOX LIGHTING TECHNIQUES
FOR PROFESSIONAL PHOTOGRAPHERS

Stephen A. Dantzig

Learn to use one of photography's most popular lighting devices to produce soft and flawless effects for portraits, product shots, and more. $34.95 list, 8.5x11, 128p, 260 color images, index, order no. 1839.

CHILDREN'S PORTRAIT PHOTOGRAPHY HANDBOOK

Bill Hurter

Packed with inside tips from industry leaders, this book shows you the ins and outs of working with some of photography's most challenging subjects. $34.95 list, 8.5x11, 128p, 175 color images, index, order no. 1840.

JEFF SMITH'S LIGHTING FOR OUTDOOR AND LOCATION PORTRAIT PHOTOGRAPHY

Learn how to use light throughout the day—indoors and out—and make location portraits a highly profitable venture for your studio. $34.95 list, 8.5x11, 128p, 170 color images, index, order no. 1841.

PROFESSIONAL CHILDREN'S PORTRAIT PHOTOGRAPHY

Lou Jacobs Jr.

Fifteen top photographers reveal their most successful techniques—from working with un-cooperative kids, to lighting, to marketing your studio. $34.95 list, 8.5x11, 128p, 200 color photos, index, order no. 2001.

MASTER POSING GUIDE FOR PORTRAIT PHOTOGRAPHERS

J. D. Wacker

Learn the techniques you need to pose single portrait subjects, couples, and groups for studio or location portraits. Includes techniques for photographing weddings, teams, children, special events, and much more. $34.95 list, 8.5x11, 128p, 80 photos, order no. 1722.

CHILDREN'S PORTRAIT PHOTOGRAPHY
A PHOTOJOURNALISTIC APPROACH

Kevin Newsome

Learn how to capture spirited images that reflect your young subject's unique personality and developmental stage. $34.95 list, 8.5x11, 128p, 150 color images, index, order no. 1843.

PORTRAIT PHOTOGRAPHER'S HANDBOOK, 3rd Ed.

Bill Hurter

A step-by-step guide that easily leads the reader through all phases of portrait photography. This book will be an asset to experienced photographers and beginners alike. $34.95 list, 8.5x11, 128p, 175 color photos, order no. 1844.

PROFESSIONAL PORTRAIT POSING
TECHNIQUES AND IMAGES FROM MASTER PHOTOGRAPHERS

Michelle Perkins

Learn how master photographers pose subjects to create unforgettable images. $34.95 list, 8.5x11, 128p, 175 color images, index, order no. 2002.

POSING TECHNIQUES FOR PHOTOGRAPHING MODEL PORTFOLIOS

Billy Pegram

Learn to evaluate your model and create flattering poses for fashion photos, catalog and editorial images, and more. $34.95 list, 8.5x11, 128p, 200 color images, index, order no. 1848.

THE BEST OF PORTRAIT PHOTOGRAPHY
2nd Ed.

Bill Hurter

View outstanding images from top pros and learn how they create their masterful classic and contemporary portraits. $34.95 list, 8.5x11, 128p, 180 color photos, index, order no. 1854.

THE ART OF PREGNANCY PHOTOGRAPHY

Jennifer George

Learn the essential posing, lighting, composition, business, and marketing skills you need to create stunning pregnancy portraits your clientele can't do without! $34.95 list, 8.5x11, 128p, 150 color photos, index, order no. 1855.

BIG BUCKS SELLING YOUR PHOTOGRAPHY, 4th Ed.

Cliff Hollenbeck

Build a new business or revitalize an existing one with the comprehensive tips in this popular book. Includes twenty forms you can use for invoicing clients, collections, follow-ups, and more. $34.95 list, 8.5x11, 144p, resources, business forms, order no. 1856.

ILLUSTRATED DICTIONARY OF PHOTOGRAPHY

Barbara A. Lynch-Johnt & Michelle Perkins

Gain insight into camera and lighting equipment, accessories, technological advances, film and historic processes, famous photographers, artistic movements, and more with the concise descriptions in this illustrated book. $34.95 list, 8.5x11, 144p, 150 color images, order no. 1857.

PROFESSIONAL PORTRAIT PHOTOGRAPHY
TECHNIQUES AND IMAGES FROM MASTER PHOTOGRAPHERS

Lou Jacobs Jr.

Veteran author and photographer Lou Jacobs Jr. interviews ten top portrait pros, sharing their secrets for success. $34.95 list, 8.5x11, 128p, 150 color photos, index, order no. 2003.